But the tranquillity of soul that grows
 From holy living and a conscience clean,
Sweeter than fragrance of the new blown rose,
 Clearer than stainless heights of heaven serene,

O fortune, with that blessing crown my friend,
 With that divine content, that golden ease
The pure in heart alone may comprehend, —
 So bring my friend the olive boughs of peace!
 Celia Thaxter.

One Woman's Work

The Visual Art of Celia Laighton Thaxter

CELIA LAIGHTON THAXTER
1835–1894

One Woman's Work

The Visual Art of Celia Laighton Thaxter

SHARON PAIVA STEPHAN

PORTSMOUTH ATHENAEUM
in association with
ISLES OF SHOALS HISTORICAL AND RESEARCH ASSOCIATION

PETER E. RANDALL PUBLISHER
PORTSMOUTH, NEW HAMPSHIRE

EXHIBITION ITINERARY:

Portsmouth Athenaeum,
Portsmouth, New Hampshire:
June 29, 2001–September 29, 2001

Society for the Preservation
of New England Antiquities,
Boston, Massachusetts:
October 15, 2001–April 12, 2002

New Hampshire Historical Society,
Tuck Library,
Concord, New Hampshire:
May 4, 2002–October 19, 2002

First Edition

Library of Congress Cataloguing—in Publication Data

Stephan, Sharon Paiva
One woman's work : the visual art of Celia Laighton Thaxter/
Sharon Paiva Stephan.--1st. ed.
 p.cm.
"Portsmouth Athenaeum in association with Isles of Shoals Historical
and Research Association" exhibit catalogue; Portsmouth Athenaeum,
Portsmouth, N.H., June 29-Sept. 29, 2001; Society for the
Preservation of New England Antiquities, Boston, Mass., Oct. 15,
2001-Apr. 12, 2002; The Museum of New Hampshire History.,
Concord, N.H., May-Sept. 2002.
 Includes bibliographical references and index.
 ISBN 0-914339-95-8 (alk. paper).
 1. Thaxter, Celia, 1835-1894--Exhibitions. 2. Thaxter, Celia, 1835-
1894--Contributions in art--Exhibitions. 3. China painting--United
States--History--19th century--Exhibitions. I. Thaxter, Celia 1835-
1894. II. Portsmouth Athenaeum (Portsmouth, N.H.) III.Title.
NK4605.5U63 T472 2001
709'.2--dc21

 2001041620

COVER: *Courtesy Portsmouth Athenaeum.*

ENDLEAVES: *Celia Laighton Thaxter, greeting card with olive branch* (Olea),
1887, watercolor. Courtesy Portsmouth Athenaeum.

FRONTISPIECE: *Courtesy Celia Thaxter descendant.*

CONTENTS PAGE: *Celia Laighton Thaxter, sketchbook, watercolor. Courtesy
Portsmouth Athenaeum.*

Contents

C.T.

Yes I do believe
That you are near
So close to me
In the rote of the sea
And in the wood
Mid leaf and branch
The bird calls all
Echo your thrall
Along the beach
We talk with each
Small shell and stone
The sea has thrown
The ebbing wave
absorbed by sand
finds you and me
walking hand in hand

<div style="text-align:center">TO CT FROM CTH</div>

Foreword

Celia Thaxter's garden grew miraculously
because she loved every flower in it.
Heart and hand were always one when
Celia did anything—poems, gardens,
midwifery—and again it is true
as she takes the brush to paint.
Love is the magical force of everything
that Celia Thaxter did and was.

CELIA THAXTER HUBBARD

Acknowledgments

The seeds for this book and the exhibition it accompanies were originally planted in Texas prior to a 1997 conference I cosponsored with friend and floral designer, Linda Anderle. It was at her urging that I began to research the artists of the Isles of Shoals and in particular Celia Thaxter's visual art. She was my generous collaborator for this entire endeavor and has additionally served the project as public relations coordinator.

Meeting Maryellen Burke very early in my research at the Portsmouth Athenaeum was both an asset and a gift. As a member of the exhibition steering committee and essay editor for this volume her advice and assistance has been indispensable. She is an inspiring role model and an unwavering source of encouragement and support.

As this project grew so did the demands for accurate documentation. Gayle Patch Kadlik, our registrar quickly became invaluable, offering expert help not only with the selection, organization, and description of objects, but also as an advisor for constant day to day decisions.

One Woman's Work is our joint effort and I owe each of these three women my deepest thanks.

I am especially grateful to Celia Thaxter Hubbard, great granddaughter of Celia Laighton Thaxter, an artist herself and the primary keeper of the Celia Thaxter legacy, for her generosity, her enthusiasm, and her interest.

I also thank Jonathan Hubbard, Thaxter's great, great grandson for his guidance, encouragement, and unwavering support throughout the development of this project.

Over the last twenty years, the work of Celia Thaxter has climbed from mere obscurity to being the creative inspiration for this traveling exhibition, *One Woman's Work: The Visual Art of Celia Laighton Thaxter*. Thaxter has returned to the archives of American Women of the nineteenth century due to the tireless efforts of many dedicated and generous people. I have personally benefited from their individual contributions as well as their incredible advice, inspiration, and commitment to this project.

I thank these friends and colleagues.

John Mayer, curator at Strawbery Banke for his knowledge, resources, and professional guidance throughout the design and installation of the exhibition.

Jane Vallier, author of *Poet on Demand: The Life, Letters, and Works of Celia Thaxter,* for her leading role in returning Thaxter's work to the canon of American literature and for her enthusiastic support and her confidence in my effort to focus on Thaxter as a visual artist.

Donna Marion Titus, editor of *By This Wing: Letters by Celia Thaxter to Bradford Torrey* and Stephanie Voss Nugent, my co-writer for *Of Pirates and Poets: A Visit to the Isles of Shoals with Celia Thaxter,* for their scholarship and service throughout my ongoing study of Celia Thaxter.

Norma Mandel, Dennis Robinson, Jane Vallier, and Nancy Wetzel, contributing essayists, whose fine work and individual perspectives so validate the concept of Celia Thaxter as a renaissance woman.

In addition, I am grateful to those who never waivered.

Giny Chisholm, caretaker of Celia Thaxter's island garden, Jack Kingsbury, founder of the re-created garden, and Bob Tuttle, historian of the Isles of Shoals, for their lasting contributions.

Thaxter authors Ann Boutelle, Faye Labanaris, Julia Older, Olive Tardiff, Barbara White, and Sarah Ann Wider for sharing their scholarship.

Dennis Robinson of SeacoastNH.com and Doug Robertson of Portsmouth Book Guild for their ever-generous help in the search for Thaxter items.

Jesse Davis, Karen Denmark, Jean Gottesman, Barbara Miller, Bitsy Packard, and Susy Thurber.

Bill Anderle, John Kadlik, Bob Nugent, Ron Titus, and Fred Vallier.

Eliza Menninger.

A project such as this requires the cooperation and support of numerous individuals, committees, organizations, and institutions. I wish to acknowledge and thank them all.

Our kind lenders who have loaned their precious objects to the exhibition.

The Thaxter Steering Committee members: Maryellen Burke, Jonathan Hubbard, Peter Lamb, and Vicki C. Wright for sharing their individual expertise and for their unfailing commitment to "One Woman's Work: The Visual Art of Celia Laighton Thaxter."

The Rosamond Thaxter Foundation, as well as the Benjamin Allen Rowland Cultural and Environmental Fund, the Winthrop L. Carter, Jr. Fund for Historic Preservation, and the Winebaum Fund (Advised) of the Greater Piscataqua Community Foundation for funding this effort.

At the Portsmouth Athenaeum: Thomas Hardiman, Jr., Keeper; Jane Porter, former Keeper; Lynn Aber, Rose C. Eppard, Deborah Child, Marcia Jebb, Wendy Lull, Sandy Smith, Richard Winslow, Sherry Wood, and Ursula Wright, as well as the members of the ArtsAthenaeum Committee chaired by Patricia Heard.

At the Isles of Shoals Historical and Research Association: Donna Titus, President; Peter Lamb, former President; Virginia Chisholm, Malcolm Ferguson, Wendy Lull, Dennis Robinson, Robert Tuttle, and Janice Warren.

At the Society for the Preservation of New England Antiquities: Ken Turino, Director of Exhibitions and Programs and Adria Bernier, Assistant Registrar.

At the New Hampshire Historical Society: John L. Frisbee, Executive Director; Linda Burroughs, former Director of Development and Marketing; Marie Hewett, former Director of Programs; and Janet Deranian, Director of Collections and Exhibitions.

At Star Island Corporation: Paul Jennings, Manager; Dan Fenn, Chairman of the Vaughn Cottage Committee; Gayle Kadlik, curator; Joy Thurlow Leclair, past curator; and Ed Rutledge, Island Registrar.

At Shoals Marine Lab: Jim Morin, Director; Marjorie Olds, former Director of Development; and Christine Bogdanowicz, Program Coordinator.

At the University of New Hampshire: Christopher Kies, Department of Music, and Larry Robertson, Department of Theatre and Dance.

At the Smithsonian's National Museum of American Art: Mark Palombo, Department of Paintings; Lynn Putney, Department of Prints, Drawings, and Photographs; Steven Edwards, and Gwen Everett; at the Metropolitan Museum of Art: Barbara Burn; and at the Strawbery Banke Museum: John Mayer and Carolyn Roy.

At the Henry E. Huntington Library and Museum: Virginia J. Renner, Librarian for Reader Services; at the Portsmouth Public Library: Sarah Hartwell; at the Miller Library, Colby College: Nancy Reinhardt, Special Collections Librarian; at the Dimond Library, University of New Hampshire: Dale Valena and Terri Trembly; and also the staffs at the Houghton Library at Harvard University, the Boston Athenaeum, and the Boston Public Library.

I thank my extended family for their sustaining faith in me and their extraordinary support of this project. My daughters Tiffany and Shelby have proofread manuscripts, filed and collated copies, edited drafts and listened to endless issues. They have supported me with love and wisdom and I am very grateful. And lastly, for his gift of time, for his patient, generous support, and for his love, I dedicate this book to my dear husband Bill.

Sharon Paiva Stephan

Celia Laighton Thaxter, illustrated page—sailboat, watercolor over set type, from Celia Thaxter, Poems, 1891. Courtesy Bill and Sharon Stephan.

Contributors

We are most grateful to the descendents of Celia Laighton Thaxter whose very generous contributions of time, funds and precious possessions have made this exhibition possible and to the philanthropic foundations that have supported our endeavor.

The Rosamond Thaxter Foundation

Ann and Jonathan Hubbard

Margaret and Eliot Hubbard III

Celia Thaxter Hubbard

Greater Piscataqua Community Foundation

We also acknowledge with gratitude the additional support from descendents of the Laighton and Thaxter families.

Martha DeNormandie

Analee P. Durant

Anne Forbes

Eliot Hubbard IV

Mary and Nicholas Hubbard

Sarah Hubbard Krieger

Lenders to the Exhibition

Martha DeNormandie

Celia Thaxter descendant

Celia Thaxter Hubbard

Margaret V. H. Hubbard

Mr. and Mrs. Fred McGill

Miller Library, Special Collections, Colby College

Bruce and Carole Parsons

Portsmouth Athenaeum

Prudence C. Randall

Sandra Smith

Society for the Preservation of New England Antiquities

Bill and Sharon Stephan

Strawbery Banke Museum

Donna Marion Titus

Vaughn Cottage Memorial Museum and Library, Star Island Corporation

Preface

Each summer, people come to the Seacoast of New Hampshire and Maine from all over in search of the local legend Celia Laighton Thaxter. They stand in her re-created garden on Appledore Island; they visit her permanent exhibit on Star Island. Some research her letters, photographs, and china pieces at the Portsmouth Athenaeum in Portsmouth, New Hampshire. Throughout the year, plays and lectures in the area about Thaxter are crowded to capacity. Although for many years in the mid-twentieth century Thaxter's literary work fell out of favor, it would appear true that, as one Thaxter aficionado put it, "Celia wants to be famous again."

Celia Thaxter was very famous in her own time. Some say she was the most popular woman writer in America in the late nineteenth century. Her poetry was as widely read as that of Whittier and Longfellow. She was famous not only for her writing but also for her summer salons on Appledore Island, where she played host to the artistic and literary heroes of the day. Twentieth-century scholars began to rediscover Thaxter as part of a women's studies effort. Today, *One Woman's Work: the Visual Art of Celia Laighton Thaxter* rediscovers something else: Thaxter was also a talented *visual* artist. In contrast to her most famous Impressionist friend, Childe Hassam, Thaxter painted objects with a delicate realism and a naturalist's eye for detail. Another reason for her recent acclaim stems from her subject matter: useful and decorative objects. Decorative arts, entertaining, and gardening have gained interest in the last decade, as witnessed by a myriad of new catalogs, books, courses, television shows, and so on. Thaxter's functional art resonates with today's renewed interest in decorating and home furnishing. Her spare china painting and delicate book illustrations have a restraint that is distinctly contemporary.

A number of other factors have aligned to build the Thaxter enthusiasts. New England audiences have been fascinated by the

concept of the summer artist's colony as attested by the crowds at the Currier Gallery of Art's exhibitions on the MacDowell Colony in 1996. In 1997, Design Experience held a five-day conference in Texas introducing Celia Thaxter to a wider audience. In 1999, Artists' Collaborative of New England (ACT ONE) toured the state of New Hampshire with a one-woman show, *Of Pirates and Poets—A Visit to the Isles of Shoals with Celia Thaxter*. Nationally, interest in the Isles of Shoals has grown thanks to the novel *Weight of Water* by Anita Shreve, a member of Oprah Winfrey's Book Circle.

Two years ago, a descendant of Thaxter approached some members of the Isles of Shoals Historical and Research Association (ISHRA) with the idea of exhibiting some of Celia Thaxter's artwork. A steering committee was formed and joined forces with the Portsmouth Athenaeum to shepherd the project through to completion. The seed of an idea soon blossomed into a major exhibition that would travel to three sites, from Portsmouth, New Hampshire to Boston, Massachusetts, and to Concord, New Hampshire, from 2001 to 2002.

The exhibition *One Woman's Work: the Visual Art of Celia Thaxter* gathers together for the first time her visual art, which has been held in private collections and museums: painted china, illustrated books, sketchbooks, and watercolor landscapes. This book serves as a printed record of the exhibition. The accompanying five essays educate the reader toward a more complete understanding of this woman who was so famous in her day.

The first essay, by J. Dennis Robinson, provides an introduction to Celia Thaxter and her multifaceted career. Her enduring appeal, her life with her family, her times at the Isles of Shoals, her social experiences with famous friends—all are viewed in relationship to her literary and artistic production. Next, Norma Mandel probes the significance of Thaxter's friendships within Boston's literary circle. Mandel demonstrates how friendships

with Annie Fields, James T. Fields, John Greenleaf Whittier, and others gave Thaxter support and inspiration. Jane Vallier, a biographer of Thaxter, in the third essay shifts focus to Thaxter's literary production. Vallier parallels Thaxter with Mark Twain and analyzes how Thaxter's prose was forged out of a Romantic tradition that was merging with a new and contrasting sense of Realism. Nancy Wetzel, our fourth author, describes Thaxter's famous garden and the central role it played on Appledore Island. Finally, a more intensive essay, by the exhibition curator, Sharon Stephan focuses on Thaxter's visual art and its development alongside her literary career.

The goals of this project were to make a significant contribution to the body of Celia Thaxter research and to expand the audience of people who know and understand Thaxter. It was also our intention to improve the quality and care of these historic objects. Throughout this project the committee has been continuously impressed with the beauty of Thaxter's works and words. Indeed, we do believe, Thaxter is right to want to be famous once again.

Maryellen Burke
EXHIBITION STEERING COMMITTEE MEMBER
SPRING 2001

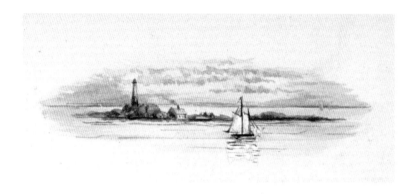

Celia Thaxter's Kaleidoscopic Appeal

Celia Laighton Thaxter, illustrated page—vignette of White Island with sailboat, watercolor over set type, from Celia Thaxter, Poems, *1882. Courtesy Bill and Sharon Stephan.*

W hy does Celia Thaxter's fame persist, even thrive in the twenty-first century? While other minor Victorian American poets and artists have long faded from public view, her writing is still published and analyzed, her life studied and dramatized, and her artwork collected and exhibited. More than a hundred years after her death in 1894, Thaxter retains a small but avid following. One dedicated group annually revives her historic island garden on Appledore, largest of the nine Isles of Shoals. There is even talk of reconstructing her cottage on the island. She appears briefly as a character in the best-selling novel *The Weight of Water* and has recently inspired a one-woman theatrical production, a coloring book, numerous fictional and factual biographies, a Web site, a music cassette, and even a woman's artistic retreat in Texas. Her kaleidoscopic appeal derives from the interplay of the many colorful overlapping roles in her life. While Shakespeare presents his seven stages of man, Celia Laighton Thaxter offers us at least a dozen intriguing phases of her life as a woman.

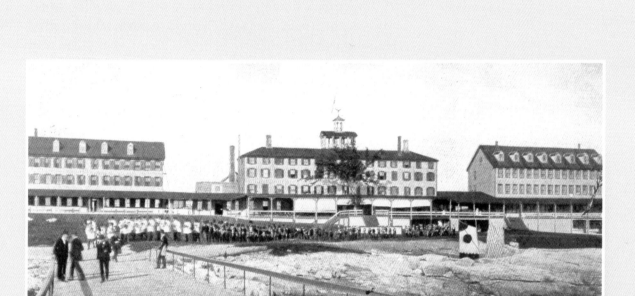

Appledore House, Isles of Shoals, c.
1880–1900, The Hugh C. Laighton Co.,
Portland, Maine, penny postcard. Courtesy
Bill and Sharon Stephan.

It is possible simply to step through these many roles—child, wife, mother, poet, caregiver, hostess, businesswoman, artist, journalist, sister, naturalist, celebrity. Placed end-to-end they form a chronological account of Thaxter's life. Taken individually, each is a tinted glass through which we glimpse a colorful facet of the complex character of Celia Thaxter. New admirers may "discover" her, for instance, through an anthologized poem, an early postcard of an old hotel, a bit of decorated china, a ferry ride to the Shoals, or a painting by Childe Hassam. Once discovered, one aspect of Celia Thaxter's life leads quickly to another. The rocky tale of her marriage to Levi Thaxter and her life among family on the Shoals are bound up in her writing, just as her painting is intimately connected to her love of nature. The many roles she assumed are anything but linear. They return and repeat, overlap and inform one another in rich cycles of time and tide.

For newcomers, Celia Thaxter is a quick study. Her poetry and prose fill only a few thin volumes and her exceptional writing can be consumed in a week of dedicated study. Despite her national appeal as a romantic poet in the second half of the nineteenth century, today Thaxter's fans hail largely from the three New England states visible in one panoramic glance from the Isles of Shoals—Maine, New Hampshire, and Massachusetts. Each state stakes its claim on her, and rightfully. But she remains forever linked to the tiny barren islands where she lived at least half her days and where she is buried. Her volume of collected letters and published correspondence with her two brothers and with close friend Annie Fields round out the canon of work and shed extraordinary light on her intriguing life. Currently, besides a one-room summer museum display in Vaughan Cottage on Star Island, Celia Thaxter's visual work and memorabilia know no permanent home. Barely a half dozen studies of her life and work are available, including the biography *Sandpiper* by her granddaughter Rosamond Thaxter and prefaces to writing by nearby Maine author Sarah Orne Jewett. A small but well-pre-

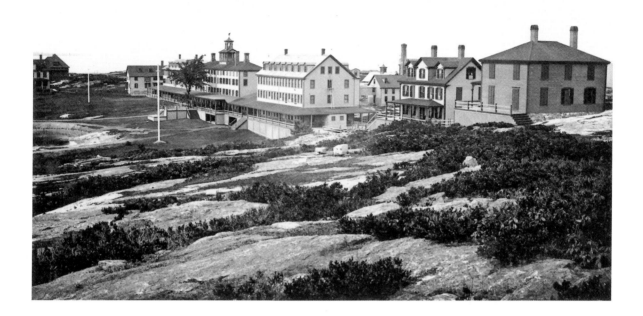

served archive of Thaxter photographs offers a precious visual map of the artist's fifty-nine years.

It is in fact this small cache of "Thaxteriana" that allows new readers to become schooled in her works and history as quickly as a new visitor may tour tiny Star, Appledore, or Smuttynose Island. But as with these islands, visitors are often compelled to come back again and again to Thaxter's life and art. Each visit offers undiscovered viewpoints. Each visit increases the sense of familiarity and connectivity, indeed even of ownership and stewardship that Thaxter readers and "Shoalers" both describe. Each return trip adds new shapes and colors to the reader's personal kaleidoscope.

Appledore House and cottages, Appledore Island, c. 1880–1910, photograph. Courtesy Portsmouth Athenaeum, Lyman Rutledge Collection.

The Child

Born in downtown Portsmouth, New Hampshire, in 1835, "the island poet" today personifies the isolated rocky Isles of Shoals just ten miles out from the state's only major harbor. Four years later her father, Thomas Laighton, accepted the post of Shoals lighthouse keeper, pulling his wife, Eliza, and daughter, Celia, from the bustle of the city to the harsh isolation of White Island. Even today the island is stark and barely accessible by boat, yet Thaxter seems to have cherished her time growing up there with baby brothers Oscar and Cedric. In her poetry and prose Thaxter paints vivid romantic images of time as the lighthouse keeper's daughter. Bleak, frigid, claustrophobic winters are transformed into innocent years of familial happiness on what must be—with the exception of Mount Washington—the most rugged, weather-torn rock in the Granite State.

Thaxter offers a captivating tale of her childhood in the endlessly popular prose work *Among the Isles of Shoals*. Portsmouth author Anne Molloy recast the story into her children's book *Celia's Lighthouse*. First published in 1949, this novel remains the ideal introduction to the Thaxter legend for young readers.

Passing White Island today aboard the ferry named for her father, summer visitors often hear Celia Thaxter's story for the first time from the narrated tour broadcast over the ship's loudspeaker. During summers, the Laightons lived on nearby Smuttynose Island, which they owned, and managed the Mid-Ocean House there. Early guests included writers Nathaniel Hawthorne, John Greenleaf Whittier, and Richard Henry Dana. Growing up among such notables, Celia lived, for a time, in the Haley Cottage, which survives on Smuttynose today. By 1847 the family had settled permanently at Hog, largest of the isles, which they renamed Appledore and on which they built their tourist hotel.

Thomas Laighton, Isles of Shoals Steamship Company, dockside on Star Island.

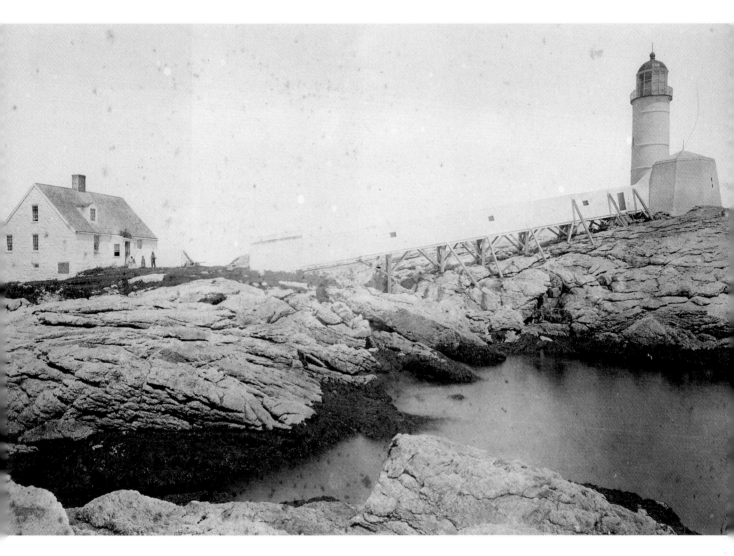

White Island Lighthouse with three figures,
c. 1850, photograph. Courtesy Portsmouth
Athenaeum, Lyman Rutledge Collection.

The Wife

Celia Laighton's innocence ended abruptly in 1851 when at sixteen she married her twenty-seven-year-old former tutor Levi Lincoln Thaxter, who had also been her father's business partner in the risky island hotel trade. Homeschooled, except for a brief semester at Mt. Washington Female Seminary in Boston, the young wife owed her view of the outside world to her husband and mentor. That worldview tarnished quickly as the couple divided their time between the Isles and various borrowed homes in Massachusetts. Nine months later Karl, who suffered from birth defects, was born at the Isles. Sons John and Roland followed in quick succession.

It has become fashionable recently to fault Levi Thaxter for the slow dissolution of the marriage. Born to privilege and drawn to philosophy and the arts, he drifted among jobs, never finding his true calling, except perhaps as a powerful reader of Browning's poetry. Fearful of the sea after a near disastrous boating trip, Levi disenfranchised himself early from the Shoals—even as Celia was becoming the island muse. He was often ill, appeared jealous of his young wife's fame, and refused to allow her to hire a housemaid even with her own earnings.

But in defense of Levi Thaxter, despite his demons, he persevered. Although they never divorced, the couple's repeated separations make their fractured household seem modern to contemporary readers. During part of the bloody Civil War, Levi Thaxter stayed in their Newtonville, Massachusetts, home with all three children while his wife was on the Shoals. Traveling south to Florida, even Jamaica, to ease his rheumatism, Levi often took John and Roland—with the aid of a housekeeper at times. The family would reunite, then go their separate ways. In 1880, with their children grown, the couple purchased the 186-acre Champernowne property in Kittery, Maine. Though closer in proximity, their emotional separation was complete and they never lived together again. Levi died four years later and is buried at Kittery Point on the mainland, ten miles in from the Shoals.

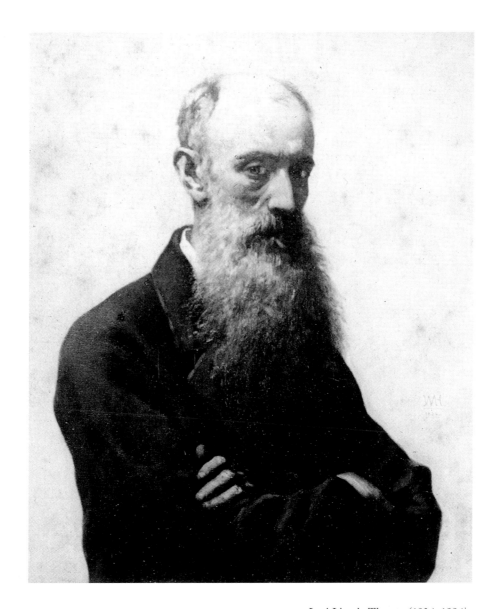

Levi Lincoln Thaxter, (1824–1884),
photograph. Courtesy Celia Thaxter
descendant.

The Mother

Of the photographs of Celia Thaxter, none is more poignant than a profile view of the teenaged mother staring into the distance, two of her active boys in tow. She seems to have often overlooked her children in real life as well. She was frequently distant from them, except for Karl, whose mild retardation and fits of temper were more than husband Levi could handle. Except for short periods with his father and at a special school, Karl remained in his mother's care until her death.

Her own unique and isolated childhood left Celia Thaxter with an active imagination and a sense of wonder that are at the heart of her writing for children. A frequent contributor to such popular periodicals as *Young Folks*, Thaxter's letters to her own sons are more didactic than playful. The combined work of running the hotel, caring for her parents, keeping up her own household, writing, and entertaining visitors seems to have left little time for parenting. The younger boys lived more in their father's domain, accompanying him on hunting trips to the South. John grew partial to farming and Roland graduated from Harvard to become, in Celia's words, a professor of cryptogamic botany. In her final years, the island poet blossomed as a grandmother, and lavished her affections on Roland's children when they visited the Isles. As the juvenile book industry flourished, she became, essentially, a grandmother to thousands of children who read her short prose work, listened to her colorfully illustrated books at bedtime, and recited her poems in school.

The Poet

The publication of "Land-Locked" in the *Atlantic Monthly* in 1861 kicked off Celia Thaxter's poetic career. The twenty-seven-line poem eloquently expressed her longing for the Shoals as she struggled to be a dutiful Massachusetts housewife. She wrote for love and for the money that was so necessary to a household with

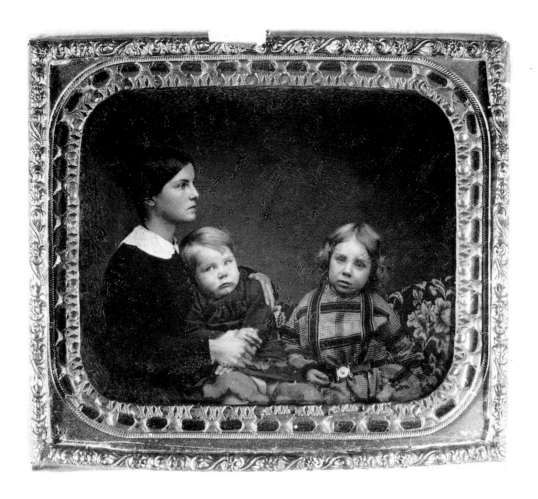

Celia Thaxter with sons John and Karl, 1856, photograph. Courtesy Celia Thaxter descendant.

husband Levi usually between jobs. Like that of many of her Victorian colleagues, a good deal of Thaxter's poetry is just too forced and sentimental for the modern ear. Some is not well crafted, written—as she confessed—"between the pots and the kettles" during stolen breaks from her endless chores and duties. But some simply sparkles.

Most of her best work centers on the Shoals and the sea. Her musings on the graves of fourteen sailors shipwrecked on Smuttynose, for example, telegraphs her empathy for the mates of those lost men. Her effort at imagining a ship lost at sea or crashing into a giant iceberg is less powerful than when she recalls the feelings of a child waiting for her father to arrive safely home or the movements of a single sandpiper across the beach. Only a few scholars have treated Thaxter's work seriously. Jane Vallier's study *Poet on Demand* has remained the primary analysis for nearly two decades. Although Thaxter's poetry never reached the consistent power of her younger contemporary Sarah Orne Jewett, her verse continues to be published and anthologized well after her death.

The Caregiver

Thaxter's adult life can be read as an unrelenting series of caregiver episodes. Her son Karl required a lifetime of attention, accompanying her nearly everywhere except during her brief tour of Europe with brother Oscar. The long illness of her mother, Eliza Laighton, and then of her father, Thomas, took their toll on Celia Thaxter, just as her own children were approaching independence. It is difficult to imagine the effort required to provide her parents with food, warmth, cleanliness, and comfort on a barren island throughout a killing New England winter. Husband Levi, too, was often ailing and Thaxter was responsive to the health and needs of her many friends as well, and all this while overseeing a summer hotel with as many as three hundred guests.

OPPOSITE, TOP: *Edmund Henry Garrett, Appledore House, 1877, ink and wash. Courtesy Star Island Corporation*

BOTTOM: *The Thaxter cottage and Celia Thaxter, Appledore Island, c.1880s, photograph. Courtesy Celia Thaxter descendant.*

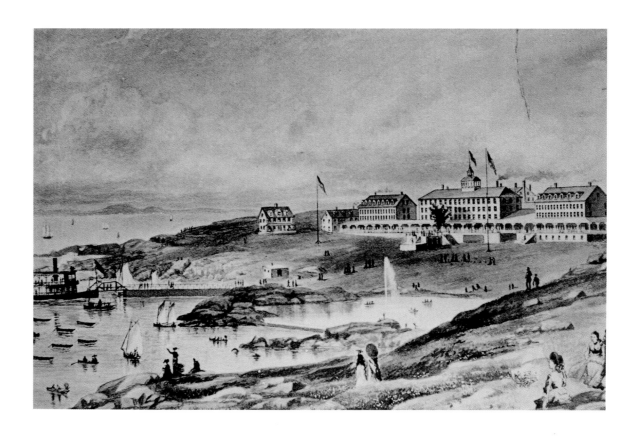

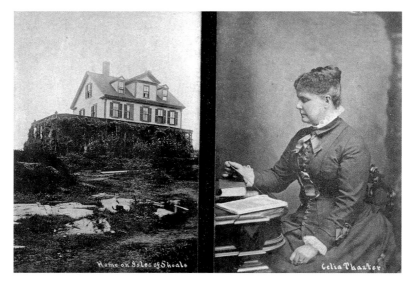

Home on Isles of Shoals

Celia Thaxter

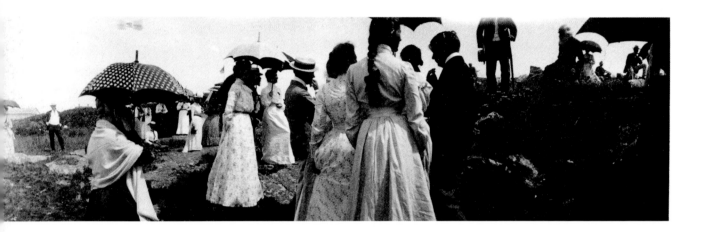

Indeed, this sense of moral duty may have bound her even closer than poetry to kindred spirit John Greenleaf Whittier. Never married, a devout Quaker and abolitionist, he lived in Amesbury, Massachusetts, with an aunt, his aging mother, and sickly sister. Whittier frequently brought his sister to the Shoals for the healing air and later attended Celia's summer salon of artists. The two formed a mutual admiration society, and a deeper caring bond. Thaxter was in constant contact with the aging poet until his death and appears in a photograph among mourners at the Whittier garden funeral in 1892, shortly before her own death.

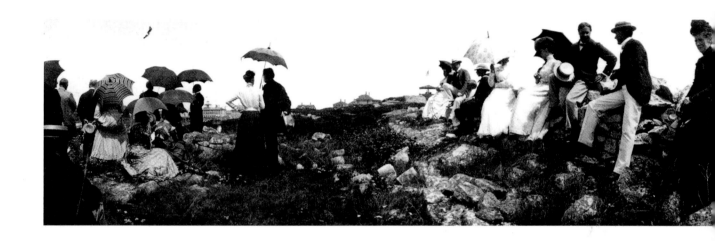

The Hostess

People liked Celia Thaxter. She seems to have made a favorable impression on practically all the painters, musicians, and writers who stayed at her family hotels and visited her famous Appledore cottage salon where she held court throughout the summers. Her father was known to be taciturn and blunt; her mother, extremely overweight, could be shy and withdrawn. Hardworking and innovative, though not always successful, Celia Thaxter's brothers Oscar and Cedric offered her the limelight—one more weighty responsibility. So, in addition to her daily attentions to the constant flow of guests, Celia Thaxter catered to a who's who of late nineteenth-century notables, from Henry Wadsworth Longfellow and Childe Hassam to Richard Henry Dana and future U. S. president from New Hampshire, Franklin Pierce. Every guest at her family's hotel, no matter how entertaining, she understood, also wanted to be entertained.

Guests socializing on Appledore Island, c. 1880–1900, photograph. University of New Hampshire, Instructional Services, The New Hampshire Collection.

The Businesswoman

Not much is made of Celia Thaxter's business acumen. That role is most often assigned to the men in her life, yet it deserves consideration. Like her brothers, she was raised by one of the region's most daring entrepreneurs. The Laightons managed hotels on three of the islands, creating a tourist destination point where none had existed. While brothers Oscar and Cedric managed the hotels with mixed success after their father's death, the family business survived nearly half a century.

Celia Thaxter, meanwhile, was simultaneously a professional writer. The success of her writing and the success of the hotels are intimately connected. Her celebrity was a major tourist attraction and her magazine writing doubled as public relations. *Among the Isles of Shoals* can be read as a thinly disguised travel brochure for the Appledore Hotel.

In her letters we see she is aware and proud of her capacity as breadwinner. She sold much more than books and hotel reservations. She signed and sold carte visa images and watercolors. Her painted china, while nourishing her soul, also helped pay the bills. Like modern media stars, she even endorsed commercial products, and her likeness appeared on advertisements selling products as diverse as typewriters and cigars.

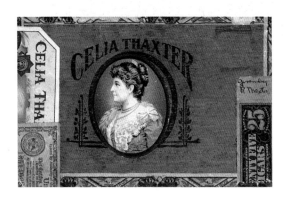

Cigar box lid (both sides) with name and image of Celia Thaxter, 1901, C.B. Henschel Manufacturing Company. Courtesy Star Island Corporation, on deposit at Portsmouth Athenaeum.

The Artist

The twenty-first century vision of Celia Thaxter as a renaissance woman on the verge of liberation owes much to the rediscovery of her life as a visual artist. Although untold thousands have experienced her writing, few have seen, touched, or owned a delicate piece of her hand-painted china. Here, independent of language, Thaxter found her most joyous and creative outlet. The

clean, unadorned beauty of her painted flora and fauna at times outstrips her word pictures. It is the message of the recent exhibition, "One Woman's Work: The Visual Art of Celia Laighton Thaxter," to showcase her enormous versatility as an artist. This is a woman, we discover, who could expertly grow a flower, paint it onto china, turn it into a verse, or arrange it in a vase—all with equal skill.

The Journalist

Despite her considerable reputation as a poet, it is Thaxter's small prose canon that best weathers the ages. *Among the Isles of Shoals* is eminently readable today and remains a useful guide to the Shoals that, in many ways, has changed little since the slim volume first appeared in 1873. Thaxter wrote it only after the constant urging of her Boston editor, James T. Fields, and her friend Whittier. It immediately eclipsed a competing Shoals history by John Scribner Jenness, published the same year. Jenness's book, a well-researched and well-written chronology is the superior history. But what Thaxter lacks in content, she makes up for in evocative storytelling and a sense of place that makes her book feel less about the Shoals than somehow distilled from the islands themselves.

Eighteen seventy-three was also the year of the brutal double murder on Smuttynose Island. One of the murder victims had been a recent employee of the Thaxter family and the author was among the first to interview Maren Hontvet, the only survivor. Her powerful prose account of the "Memorable Murder" appeared in *Harper's* in 1875 and is among her most highly anthologized pieces.

An Island Garden was published in 1894, just before Thaxter's death. Today it is probably the best-known volume ever written

about the Isles of Shoals, thanks in part to accompanying illustrations by Boston Impressionist Childe Hassam. Here again Thaxter writes with ageless clarity about what she knew best.

The Sister

It is all too easy, even for those who know Thaxter's life well, to imagine her simply as a child or as a white-haired woman, or stuck somewhere in between. We have little information from her children, husband, or parents to soften the familiar stages. Luckily, Celia Thaxter's affectionate connection with brothers Oscar and Cedric is preserved in two books. These precious volumes, still available today—help flesh out the artist's character in the eyes of her longest-surviving companions.

Oscar Laighton, who died just a few months shy of his hundredth birthday, remained unmarried and devoted to his famous sister and to the islands. Because he survived well into the Shoals era of the Unitarian religious conferences, Laighton is the touchstone between his sister's time and the present day. Elderly "Shoalers" recall Uncle Oscar in his flowing white beard and wide-brimmed hat. While Oscar dabbled with hymnals, sketches, and verse, his book *Ninety Years on the Isles of Shoals* is a loving memoir of the entire Laighton dynasty.

Cedric's letters, collected and published by Fred McGill, currently an "old Shoaler" in his nineties, are arguably the most entertaining of all the family's correspondences. Written largely while in his teens, Cedric Laighton's *Letters to Celia* offers a witty commentary on the culture clash among tourists, hard-living island natives, and the Laighton clan during summers on the Isles of Shoals. From this perspective, we get an intimate and humorous running commentary. In Cedric's world, he is Grans, Celia is Gwammy, Oscar is Bocki. One passage, pulled at random

from Cedric's letters, offers a typically lighthearted response to a recent missive from Celia. On October 24, 1864 he wrote:

Dear Sister, your cheering letter of the 20th came this morning with the photograph enclosed. The photograph is splendid; when Mother beheld it, she shrieked so violently with delight that the pollack fishermen off Peter Mathes Rock raised their heads in astonishment, and Bocki came rushing to the rescue, imagining nothing less than that the grim destroyer was at hand.

The Naturalist

Celia Thaxter was as religious a woman as her time and locale required. Hymn-singing and church services figured significantly in the life of the hotel visitors, as they do in the familiar stone Gosport Chapel on Star Island today. But Thaxter's spirituality seems almost pantheistic, derived much of the time from the tangible world, from the very boulders, grasses, seaweed, mosses, birds, and branches that made up her tiny planet. Indeed, after the loss of her beloved parents and the dissolution of her marriage, Thaxter began a search for tangible proof of her faith. In her later years, like so many others of her era, she sought answers via mediums, seances, and spiritualism.

It is also at this time that Thaxter produced *An Island Garden* and was attracted to the work of ornithologist John Audubon. Politicized, Thaxter became outspoken in the early movement to protect endangered birds, especially from the collection of rare feathers for use in women's hats. It is in her memory that much of the Shoals has become a sanctuary for birds today. Appledore Island, long the home of the family's hotel, is now a summer research institute for marine biology managed by Cornell and the University of New Hampshire. Shoals Marine Lab students, like Thaxter, find the region to be the ultimate classroom for the study of science amid a landscape of poetry.

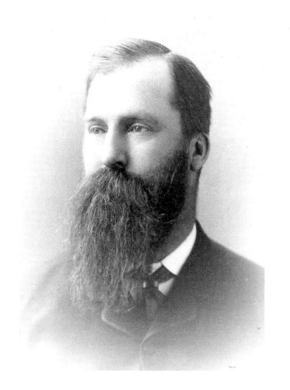

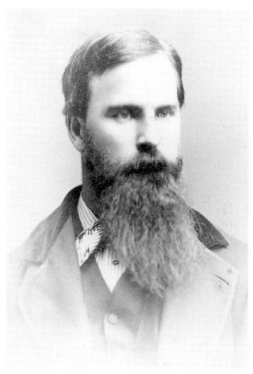

*Cedric Laighton, Celia Thaxter's brother
(1840–1899), photograph. Courtesy Star Island
Corporation, on deposit at Portsmouth Athenaeum.*

*Oscar Laighton, Celia Thaxter's brother (1839–1939),
photograph. Courtesy Star Island Corporation, on
deposit at Portsmouth Athenaeum.*

The Celebrity

A century-old card game testifies to the poet's fame among her contemporaries. An 1897 edition of Authors, published in Cincinnati, includes a playing card of Celia Thaxter among the fifty most famous English and American writers of all time. Milton, Dickens, Pope, Shakespeare, and Twain share the deck with Thaxter, as well as her Portsmouth, New Hampshire contemporary and editor Thomas Bailey Aldrich.

In her time Thaxter dined as a peer with Charles Dickens and her work was compared favorably to the prose of Mark Twain and the verse of her friend Whittier. In our media-soaked era, when celebrity is often regarded well ahead of talent, Thaxter's "staying power" as a superstar deserves special note. In New England, many who have never read or seen her work still recognize her name.

Isn't she that Island Poet, people will say, the one with the garden? So she still is, although her cottage burned to its foundation and her hotel has been gone almost a century. She's still the little girl who lived in the lighthouse too, and an artist, and more. With every twist of the kaleidoscope, we see a surprising new perspective on this woman's life and art.

J. Dennis Robinson

Land-Locked

Black lie the hills, swiftly doth daylight flee,
 And catching gleams of sunset's dying smile,
 Through the dusk land for many a changing mile
The river runneth softly to the sea.

O happy river, could I follow thee!
 O yearning heart, that never can be still!
 O wistful eyes, that watch the steadfast hill,
Longing for level line of solemn sea.

Have patience,— here are flowers and songs of birds,
 Beauty and fragrance, wealth of sound and sight,
 All summer's glory thine from morn till night,
And life too full of joy for uttered words.

Neither am I ungrateful:— but I dream
 Deliciously how twilight falls to-night
 Over the glimmering water, how the light
Dies blissfully away, until I seem

To feel the wind sea-scented on my cheek,
 To catch the sound of dusky flapping sail
 dip of oars, and voices on the gale
Afar off, calling low;—my name they speak!

O Earth! thy summer song of joy may soar
 Ringing to heaven in triumph. I but crave
 The sad, caressing murmur of the wave
That breaks in tender music on the shore.

Celia's Friends

I had a friend named Jennie who was very dear to me. She was a roommate of mine at school. She never would write to me though I begged her to and now I believe she has left school for I can get no trace of her. I hope our friendship will not end so, my dear second friend Jennie.[1]

Celia Thaxter's isolated childhood has often been depicted as idyllic, but this poignant letter confirms that she, like all children, wanted friends. This letter was written when she was sixteen and had just returned from a year at the Mt. Washington Female Seminary in Boston, her only formal schooling and her only opportunity to be with girls of her own age. Later, during the difficult years of her marriage to Levi Thaxter, friends became even more important. They formed the keystone of her creative life, encouraging her artistic and literary efforts when she felt overwhelmed by personal problems. Her closest friends were Annie and James Fields, Sarah Orne Jewett, Childe Hassam, and John Greenleaf Whittier, but there were others, less

Celia Laighton Thaxter, illustrated page—vignette of sailboats in harbor, watercolor over set type, from Celia Thaxter, Poems, *1891. Courtesy Bill and Sharon Stephan.*

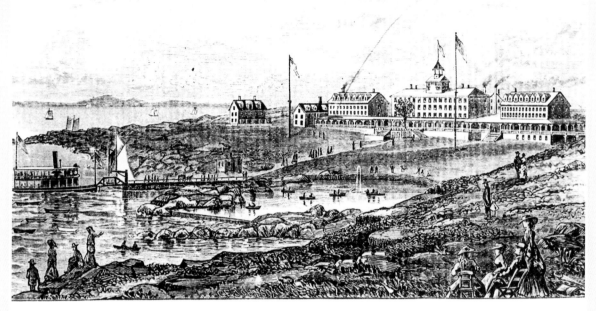

APPLEDORE HOUSE,

ISLES OF SHOALS.

LAIGHTON BROTHERS & CO. - - - PROPRIETORS.

Appledore House letterhead showing hotel and waterfront, 1878, lithograph. Courtesy Portsmouth Athenaeum, Lyman Rutledge Collection.

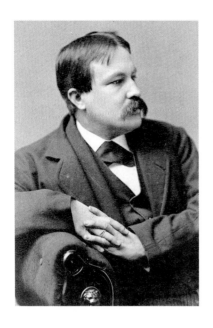 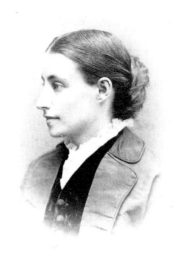 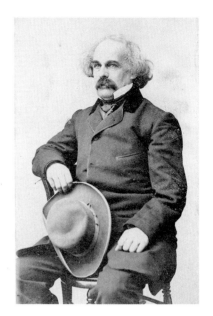

well known but equally supportive and cherished. They included Mary Hemenway, a Boston philanthropist to whom Celia dedicated *An Island Garden*; Rose Lamb, a friend and guest on Appledore; Elizabeth Curzon Hoxie, her neighbor at Artichoke Mills during the early days of her marriage; and Sarah Weiss, wife of Levi's college friend John Weiss. Many of the visitors who flocked to Appledore Island also developed friendships with their charismatic hostess.

Thaxter's most intimate friend, Annie Adams Fields, was the wife of James T. Fields, the editor of the *Atlantic Monthly* from 1861 to 1871 and one of America's leading publishers. Their friendship developed after Thaxter's first poem "Land-Locked" appeared in the *Atlantic* in 1861. The publication of "Land-Locked" turned Thaxter's life around. Overwhelmed with house-work, beginning to tire of her stay-at-home husband, she found her milieu in Boston's literary world with the help of the Fields. Both personally and historically, she was in the right place at the right time. Nineteenth-century Boston and its environs were

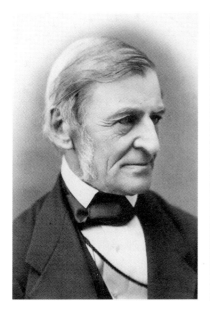 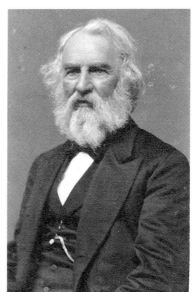

home to America's most famous authors; the cultural elite of the city were sophisticated, worldly, and well-educated men and women who not only prized arts and letters, but also were instrumental in the advancement of public education, the administration of libraries, and the development of liberal arts colleges.

The Fields and their friends also held editorial control of popular magazines, such as *Harper's, Scribner's,* and, of course, the *Atlantic Monthly.* Founded in 1857, its first editor was James Russell Lowell, Levi's cousin by marriage. James Fields succeeded him and was in charge when contributors included Oliver Wendell Holmes, Ralph Waldo Emerson, Henry Wadsworth Longfellow, John Greenleaf Whittier, Harriet Beecher Stowe—and now Celia Thaxter. The Fields immediately invited Celia and Levi Thaxter to their home, which pleased and flattered the young couple. There they met the famous authors whose works they so enjoyed; they also were asked to join their hosts at concerts and the opera, activities that provided a welcome break from their harried lives.

LEFT: *Ralph Waldo Emerson, author (1803–1882), photograph. Courtesy Star Island Corporation, on deposit at Portsmouth Athenaeum.*

CENTER: *Laura Catherine Redden, journalist, (1839–1923), photograph. Courtesy Star Island Corporation, on deposit at Portsmouth Athenaeum.*

RIGHT: *Henry Wadsworth Longfellow, poet (1807–1882), photograph. Courtesy Star Island Corporation, on deposit at Portsmouth Athenaeum.*

Although Celia Thaxter and Annie Fields's lives were dissimilar in almost every way, they immediately became devoted to one another. When they were unable to visit, they corresponded, sometimes daily; their letters reveal the compassion and empathy that distinguished their friendship from the very beginning. This letter in particular reveals the contrast in their situations and the wonderful empathy that overcame their differences:

> *Dear and beautiful Annie Adams Fields: How do you do and what do you do this seventh night of the New Year, I wonder? Would I could look in upon you, would I could see your lovely face wherever you are . . . I'm so sick of the rage of the elements...it has made poor mother sick . . . Such days and nights we have gone through! But she is a little better . . . Dearest, how is your mother? . . . O, thank all your fortunate stars you are not on a desolate island . . . but are in the centre of civilization with friends at hand, and help . . . and advice and sympathy and no end of apothecary shops to comfort and assist you! I sent an order in longing haste to a druggist in Portsmouth days ago, by that infrequent fishing boat "on which our hopes of Heaven depend," . . . and we might all die seven times before we shall see the fishing boat again or the anodynes I sent for...Annie, I'm just wild when I think of the music I can't hear . . . Love to James Fields. Do write to my forlornness, you charitable angel!* [2]

In contrast to Thaxter, Annie Fields, daughter of Boston Brahmins and wife of a famous man, lived a life of privilege. Her home at 148 Charles Street was a renowned literary salon where one might find authors, artists, and musicians from around the world. In it she re-created the ambience of an earlier age; the young Willa Cather, the urbane Henry James, and the peripatetic Charles Dickens all recorded how 148 Charles Street was, for them, a link with the past, a symbol of refinement and culture. For Henry James in particular, this association with tradition was

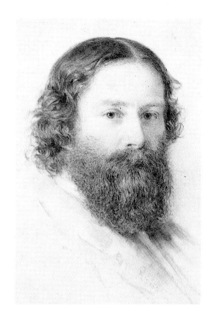

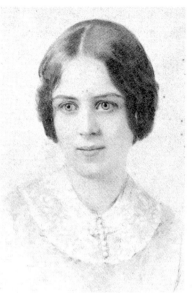

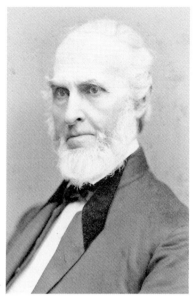

*James Russell Lowell, poet, editor
(1819–1891), photograph. Courtesy
Star Island Corporation, on deposit at
Portsmouth Athenaeum.*

*Maria White Lowell, author, wife of
James Russell Lowell, (1821–1853),
photograph. Courtesy Star Island
Corporation, on deposit at Portsmouth
Athenaeum.*

*John Greenleaf Whittier, poet
(1807–1892), photograph. Courtesy
Star Island Corporation, on deposit at
Portsmouth Athenaeum*

significant. He met the Fields in 1864 when, according to his biographer Leon Edel, "Mrs. Fields had welcomed him as a precocious young man of letters to her salon in Charles Street."[3] When he returned to America in 1904, he called on her again and described his impressions in *The American Scene*:

> *Here, behind the effaced anonymous door, was the little ark of the modern deluge . . . here still the long drawing-room that looks over the water and toward the sunset with a seat for every visiting shade . . . and relics and tokens so thick on its walls as to make it positively, in all the town, the votive temple to memory.*[4]

It was a life that Celia Thaxter, lacking money and social status, yearned for, but never fully achieved.

On a June evening in 1881, while Thaxter was visiting her friends at 148 Charles Street, James Fields died. As Annie had sustained Thaxter during the months after Thaxter's mother died, so Celia was a support and comfort after James's death. In a letter written a few months later, Celia pleaded with Annie:

> *Of all things, on earth don't shut yourself away; throw bridges over your moat and let love come to you or you will die a thousand deaths of silence, and sorrow and despair . . . Do not give up your work—what will become of you without it?*[5]

The next year Annie Fields, who was then fifty-four, and author Sarah Orne Jewett, who was thirty-three, began a twenty-eight-year relationship, ending in 1909 with Sarah's death. This friendship, called a Boston Marriage, was common in the nineteenth century, particularly among upper-class women. Helen Howe, daughter of Fields's close friend Mark DeWolfe Howe, wrote: "There were, in my parents' circle of friends in Boston, several households consisting of two ladies, living sweetly and devotedly together. Such an alliance I was brought up to hear

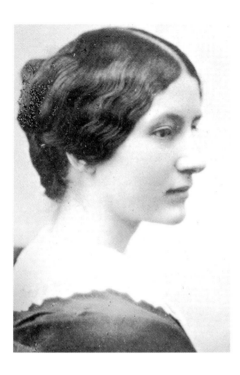 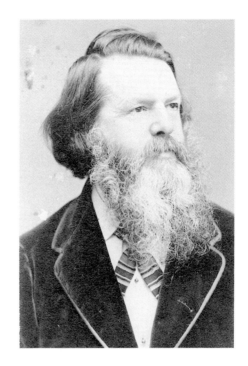

*Annie Adams Fields, author, hostess
(1824–1915), photograph. Courtesy Portsmouth
Athenaeum, Lyman Rutledge Collection.*

*James T. Fields, author, editor, publisher
(1817–1881), photograph. Courtesy Star Island
Corporation, on deposit at Portsmouth
Athenaeum.*

called a 'Boston Marriage.' "[6] During their years together Sarah wrote her best books and short stories, and Annie, while continuing to maintain her role as a hostess, also developed a reputation as a dedicated philanthropist.

Thaxter and Jewett also became fast friends; it was only natural that the two women were attracted to one another. Both were writers, although Jewett's reputation today far exceeds Thaxter's. Both had grown up in seaside communities and understood the world of men and women isolated by time and weather; each had fathers who nurtured their independence. Their love of gardens and the traditions they represented provided another important bond between the two:

> *The gardens they created were an integral part of their daily lives and surfaced in their writings as part of the intimate landscape which was celebrated in their work. In this world of household chores and endless rounds of social duties, to be alone and to be creative was an incredible act of freedom . . . To claim nature within a personal space was the joy the garden provided, enabling them to construct an intimate environment from which to observe and record the universe beyond the garden gate.*[7]

For both women, gardening provided a circumscribed sphere of activity during which they could find respite from their cares, time to think and plan, and peace and quiet in the sometimes hectic world in which they lived. In addition, each enjoyed the actual physical work of gardening, although it was sometimes difficult for Sarah, who suffered from rheumatoid arthritis. Their gardens reflected their personalities: When the Jewett sisters moved into their grandfather's house, they created a proper New England front-yard garden with its lilacs, roses, and old-fashioned perennials.[8] On the less fertile soil of the Isles of Shoals, Thaxter planted a cutting bed, small but with a magnificent display of poppies and smaller groupings of pansies,

nasturtiums, sweet peas, hollyhocks, and many other flowers carefully cultivated to adorn her parlor.

The friendship between Jewett and Thaxter was significant for both women; for Celia it strengthened her ties to Annie Fields and provided another supportive friend of her own; for Jewett, it enhanced her writing, providing her material for some of her most thoughtful work. Many have recognized a resemblance to Celia Thaxter in the character of Mrs. Blackett in Jewett's best-loved book, *The Country of the Pointed Firs*. Mrs. Blackett's warmth as a hostess and independent life on Green Island parallels that of Celia on Appledore. The relationship between Thaxter and Jewett stands as a testament to the power of friendship to enrich and enhance women's lives.

While Thaxter saw the Fields and Sarah Jewett as often as possible in Boston, Appledore, and Maine, other female friendships remained largely epistolary. Celia's letters to those who lived at a distance express her distress at not seeing them more frequently, but because of their commitment to corresponding, these women remained friends for life. In their letters they discuss everyday events and show a concern for one another's children and parents. For nineteenth-century women, corresponding was more than a commitment; it was a substitute for a visit. Most women enjoyed writing letters; mail service was frequent (often a letter written in the morning was delivered by the afternoon) and letters were eagerly anticipated. Thanks to their correspondence, these women felt less isolated; they were able to share their joys and sorrows without the necessity of being face to face. Their letters reveal a gift of sympathy, a compassion and understanding, that transcends the miles between them.

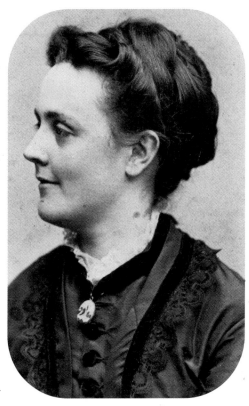

Sarah Orne Jewett, author (1849–1909), photograph. Courtesy Portsmouth Athenaeum, Lyman Rutledge Collection.

Thaxter's letters provide insights into many of her private thoughts. To Sarah Weiss, her confidante from her earliest days as a wife and mother, Thaxter often wrote of her longing to return to her beloved islands: "I do *belong* to the sea and cannot thrive away from it. I should prefer a handful of seaweed to a whole bunch of fragrant apple blossoms."[9] In letters to her year after year she shares her worries about her children, describes her own illnesses, and writes of day-to-day happenings.

In letters to her friend Lizzie Hoxie, Thaxter reveals the ups and downs of her life in her new home in Newtonville. In May 1856 she complained: "My eyes are almost shut from weariness and sleepiness."[10] Nevertheless, the following January she is all aglow and writes Lizzie of the good times she and Levi are having reading Elizabeth Barrett Browning's "Aurora Leigh" together.[11]

As the years go by, these letters reveal the growing unhappiness in Thaxter's life. The sympathy of her friends helped her to cope with the pain of her mother's death, the disappointment in her marriage, and ongoing problems with her physically and emotionally handicapped son, Karl. Poor health also plagued Thaxter's life as she grew older: Heart disease, neuralgia, and what she called "nervous prostration" are often the subject of her correspondence. Writing to a Portsmouth friend, Ada Hepworth, she reveals a sense of humor lurking behind her problems:

> *I should have written before, dear Ada, for I have thought of you much and often, but I have been fighting with nervous prostration all winter, with the waves going over me until I was well nigh drowned. I have given my strength all away all my life, and now I am bankrupt. But I am fighting my way up and out of the N. P. with the help of a wise old doctor who lives not far from here, who feeds me on champagne, which makes of me a new creature quite. But I've not much strength to write, though I have so much to talk about . . . Do come to the Shoals for as long as you can.*[12]

Nervous prostration—what today might be called depression—was not uncommon among nineteenth-century women. Many doctors prescribed water cures at fashionable spas; Thaxter's champagne treatment was unique, but obviously effective!

Celia Thaxter did not limit her friendships to women. Cedric and Oscar Laighton, her brothers and childhood playmates, were her friends throughout her life. Although they depended on her to come to the islands when their parents were ill and to help with the day-to-day running of the hotel in the summer, there was also an overriding feeling of love and companionship among the three. The brothers, despite their lack of formal education, were amazingly literate and Cedric, in particular, enjoyed writing to his sister:

> We received three or four letters from you from Vermont. I suppose now you are in California, but I'm going to send this to Newtonville and risk it. Mother says you are a beautycritter to write her such nice long letters, and we all think it is charming to read of the manners and customs of all the different places in the world. But we cannot and will not believe that the Montpelier coffee is better than ours . . .[13]

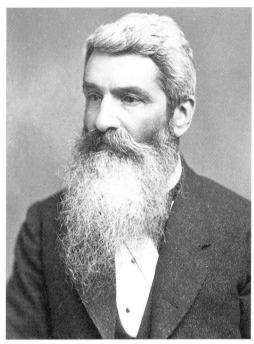

Rev. John W. Weiss, abolitionist, friend of Levi Thaxter (1818–1879), photograph. Courtesy Star Island Corporation, on deposit at Portsmouth Athenaeum.

As Fred McGill observed in his introduction to *Letters to Celia:* "There is a communication of spirit accented by the private nicknames and private jokes but essentially unspoken because it is unspeakable."[14]

Perhaps because Thaxter had been raised happily in the company of her two brothers, she was always comfortable with men. She liked and admired Levi's friend the Reverend John Weiss. James Fields was not only her editor and Annie's husband, but also a caring friend. In addition, she befriended many of the

visitors to Appledore, particularly the musicians and artists: Olé Bull, John Paine, William Mason, Ross Turner, and William Morris Hunt. And although she never met the naturalist Bradford Torrey, they had a lively epistolary friendship based on their shared love of wildlife:

> *Tell me, are you gathering pussy willows and alder catkins by the armfuls as I am here? For Goths and Vandals are hacking and hewing at everything in the lovely wild road sides . . . Why must there be such deadly enemies constructed for everything that lives! What between the shrikes and owls and cats and weasels and women, most of all! I wonder there's a bird left on this planet. They sent up sixty-eight snowy owls from Cape Neddick below this on the coast, in a batch, last month! Such wholesale butchering is something terrible. "They," I said, not women this time! but everything that wore trousers was shooting owls the first of the winter. Robins are singing at the Shoals!*[15]

But it was John Greenleaf Whittier, poet, editor, abolitionist, and a champion of the rights of women, who was her special favorite. He along with Henry Wadsworth Longfellow and Oliver Wendell Holmes were aptly called the Fireside Poets because their writing celebrated the virtues of home and hearth. Like Annie Fields, Whittier, Longfellow, and Holmes embodied those traits synonymous with gentility that Thaxter so admired.

In his poem "The Tent on the Beach," John Greenleaf Whittier describes himself as "A silent, shy, peace-loving man."[16] Historian Vernon Parrington wrote, "Among many lovable men he was perhaps the most lovable."[17] However, these comments only partially describe Whittier. He was a Quaker and an active abolitionist from his earliest days when he published his antislavery manifesto, *Justice and Expediency*. He also worked as an editor for William Lloyd Garrison at the *Newburyport Free Press*. Before and during the Civil War he was a political activist, risking phys-

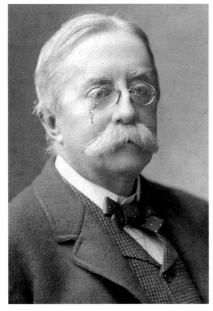 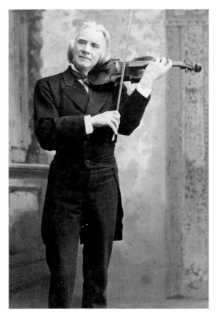

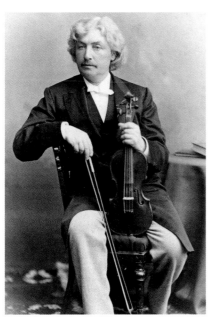 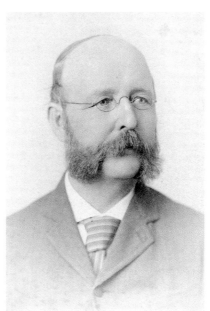

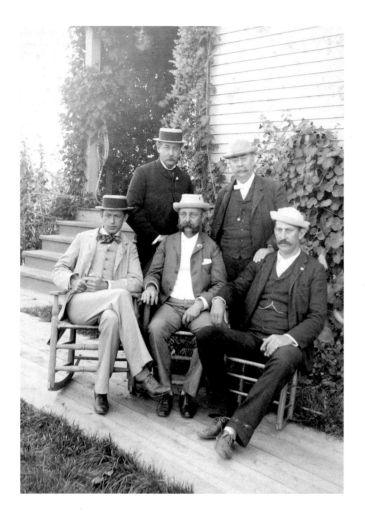

Dapper gentlemen of Appledore Island 1889. Left to right, standing: William Mason, William Winch. Seated: J. Appleton Brown, John Knowles Paine, Ross Sterling Turner; photograph. Courtesy Star Island Corporation, on deposit at Portsmouth Athenaeum.

ical danger for the cause in which he believed so ardently. Nor did his concern for African Americans end when the war was over; he helped former slaves find jobs and became one of the supporters of the Hampton Institute. In addition, he showed his commitment to equal rights for women by supporting women's suffrage and working for higher education for women (he helped found Wellesley and Pembroke Colleges). Throughout his life he fought for freedom of speech and the press and opposed capital punishment. Despite a lifetime of ill health, he diligently pursued these causes through his writing and through contributions of time and money, while always remaining loyal to his Quaker principles.

By the time Thaxter and Whittier met in 1866, he was sixty and in frail health, and Celia was only thirty-two. Nevertheless, their friendship developed quickly and continued until his death in 1892. Each of his many letters to her concluded with "Thy Friend," and each of her letters was filled with concern for his well-being.

The two had much in common: their rural backgrounds, a love of nature, an interest in spiritualism. Most important, they were both dedicated poets. Thaxter eagerly sought and listened to Whittier's advice about her writing, although most of his responses were laudatory: "I know of no one who so well describes the sea and sky and the wild island scenery. Thy pictures

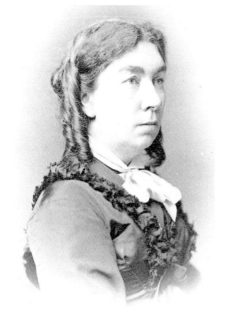

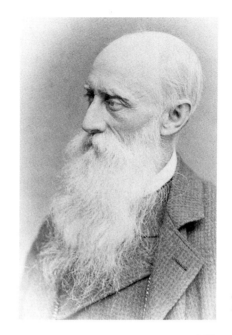

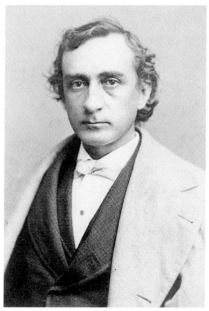

TOP: *Ellen Robbins, artist (1828–1905), photograph. Courtesy Star Island Corporation, on deposit at Portsmouth Athenaeum.*

TOP: *William Morris Hunt, artist (1824–1879), photograph. Courtesy Star Island Corporation, on deposit at Portsmouth Athenaeum.*

BOTTOM: *Edwin Booth, actor (1833–1893), photograph. Courtesy Star Island Corporation, on deposit at Portsmouth Athenaeum.*

BOTTOM: *J. Appleton Brown, artist (1844–1925), photograph. Courtesy Portsmouth Athenaeum, Lyman Rutledge Collection.*

glow with life and color. I am only afraid that I shall be tempted to appropriate them some time, they so exactly express what I feel but cannot say . . ."[18] When he was well enough, he visited Appledore, where, as Annie Fields wrote: "Occasionally he would pass whole days in Celia Thaxter's parlor, watching her at her painting in the window, and listening to the talk around him."[19] On Whittier's eightieth birthday, Thaxter sent him this poem:

Old friend, dear friend, in summer days gone by
You brought me roses delicate and fair.
That blossomed wild in our New England air.
And they are fragrant still, though dead and dry.

Now, when for us comes winter on apace,
Within the garden of my thought there grows
For you a fadeless flower, as sweet a rose
As ever summer wore with youthful grace . . .[20]

John Greenleaf Whittier was adored by many women—Lucy Larcom, Annie Fields, Sarah Orne Jewett, Lydia Child—and Celia Thaxter happily added her name to his list of admirers.

With Childe Hassam, Thaxter had a more sophisticated relationship, one that developed when her most difficult years were over and she was comfortably established in her parlor on Appledore. Hassam, the son of an old New England family, was born in 1859. He and Thaxter met when he was still in his twenties and teaching watercolor painting in Boston. After launching a successful career as a magazine illustrator, he studied art in Paris. From the mid-1880s until her death in 1894, Hassam visited Thaxter at the Isles of Shoals, enchanted both by the islands and by his hostess. He was present at her funeral, helping to carry her flower-covered coffin to the hill where she was buried. His illustrations in *An Island Garden*, reminiscent of Monet and the French Impressionists, are a testimony to their friendship.

OPPOSITE: *Karl Thaxter. Childe Hassam, artist (1859–1935), on Celia Thaxter's piazza, c. 1886, photograph. Courtesy Portsmouth Athenaeum, Lyman Rutledge Collection.*

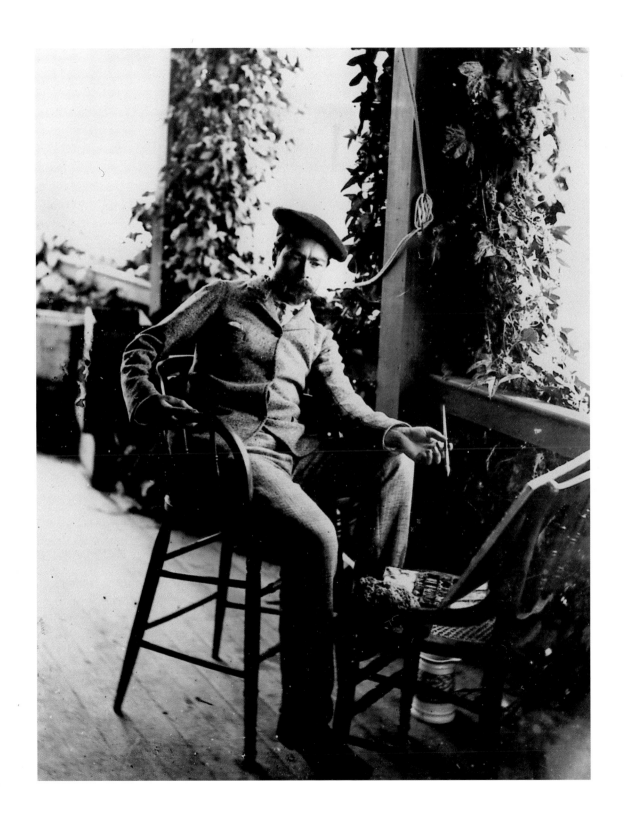

Over the years Celia Thaxter grew from a lonely, unsophisticated sixteen-year-old into a worldly, charming hostess, the doyenne of one of New England's leading salons. With the support of her friends as well as her own charm, intelligence, and talent, she achieved a lasting place in the history of the nineteenth century.

Norma H. Mandel

EXPECTATION

Throughout the lonely house the whole day long
 The wind-harp's fitful music sinks and swells,—
A cry of pain, sometimes, or sad and strong,
 Or faint, like broken peals of silver bells.

Across the little garden comes the breeze,
 Bows all its cups of flame, and brings to me
Its breath of mignonette and bright sweet peas,
 With drowsy murmurs from the encircling sea.

In at the open door a crimson drift
 Of fluttering, fading woodbine leaves is blown,
And through the clambering vine the sunbeams sift,
 And trembling shadows on the floor are thrown.

I climb the stair, and from the window lean
 Seeking thy sail, O love, that still delays;
Longing to catch its glimmer, searching keen
 The jealous distance veiled in tender haze.

What care I if the pansies purple be,
 Or sweet the wind-harp wails through the slow hours;
Or that the lulling music of the sea
 Comes woven with the perfume of the flowers?

Thou comest not! I ponder o'er the leaves,
 The crimson drift behind the open door:
Soon shall we listen to a wind that grieves,
 Mourning this glad year, dead forevermore.

And, O my love, shall we on some sad day
 Find joys and hopes low fallen like the leaves,
Blown by life's chilly autumn wind away
 In withered heaps God's eye alone perceives?

Come thou, and save me from my dreary thought!
 Who dares to question Time, what it may bring?
Yet round us lies the radiant summer, fraught
 With beauty: must we dream of suffering?

Yea, even so. Through this enchanted land,
 This morning-red of life, we go to meet
The tempest in the desert, hand in hand,
 Along God's paths of pain, that seek his feet.

But this one golden moment,—hold it fast!
 The light grows long: low in the west the sun,
Clear red and glorious, slowly sinks at last,
 And while I muse, the tranquil day is done.

The land breeze freshens in thy gleaming sail!
 Across the singing waves the shadows creep:
Under the new moon's thread of silver pale,
 With the first star, thou comest o'er the deep

1. Celia Thaxter, letter to Jennie Usher, Shoals, 10 April 1851, Colby College.

2. Celia Thaxter, letter to Annie Fields, Shoals, 7 January 1877, Boston Public Library.

3. Leon Edel, *Henry James: A Life* (New York: Harper, 1985), 470.

4. Henry James. *The American Scene* (Bloomington: Indiana University Press, 1968), 244–45.

5. Celia Thaxter, letter to Annie Fields, 23 October 1881, Boston Public Library.

6. Helen Howe, *The Gentle Americans: Biography of a Breed* (New York: Harper, 1965), 83.

7. Patrice Todisco, "By Pen and Spade" in *Hortus: A Gardening Journal* (Summer 1990), 34–35.

8. Paula Blanchard, *Sarah Orne Jewett: Her World and Her Work* (Reading, Massachusetts: Addison-Wesley, 1994), 197.

9. Celia Thaxter, letter to Sarah Weiss, Artichoke Mills, 6 February 1852, Private Collection.

10. Celia Thaxter, letter to E.C. Hoxie, Newtonville, 25 May 1856 in *Letters of Celia Thaxter*, 3.

11. Celia Thaxter, letter to E.C. Hoxie, Newtonville, 18 January 1857 in *Letters of Celia Thaxter*, 6.

12. Celia Thaxter, letter to Adaline Hepworth, Portsmouth, 8 April 1890 in *Letters of Celia Thaxter*, 174.

13. Cedric Laighton, letter to Celia Thaxter, Isles of Shoals, 20 October 1875 in *Letters to Celia* (Boston: Star Island Corporation, 1972), 162.

14. Fred McGill, *Letters to Celia* (Boston: Star Island Corporation, 1972), xv.

15. Celia Thaxter, letter to Bradford Torrey, Portsmouth, 6 February 1891, Private Collection.

16. John Greenleaf Whittier, *The Complete Poetical Works* (Cambridge: Riverside, 1894), 242.

17. Vernon Parrington, *Main Currents in American Thought* (New York: Harcourt, 1930), 361.

18. John Greenleaf Whittier, letter to Celia Thaxter, Amesbury, 24 August, 1867, Houghton Library, Harvard University.

19. Annie Fields, *Authors and Friends* (Boston: Houghton Mifflin, 1896), 314.

20. Celia Thaxter, Autograph File 172, Houghton Library, Harvard University.

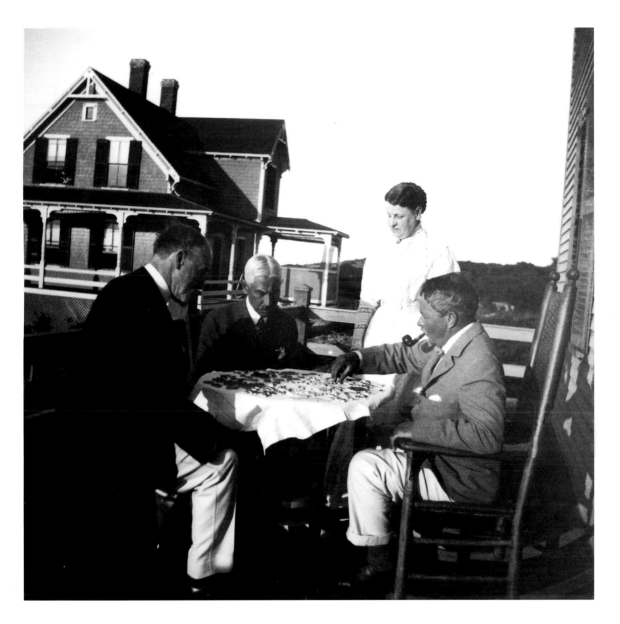

Childe Hassam (right) and unidentified guests working on a puzzle, Appledore Island, c. 1912, photograph. Courtesy Portsmouth Athenaeum, Lyman Rutledge Collection.

The Literary Landscape of Celia Thaxter

Celia Laighton Thaxter, illustrated page—seashore, watercolor over set type, from Celia Thaxter, Poems, *1891. Courtesy Bill and Sharon Stephan.*

L andscape or seascape? What direction would a young writer such as Celia Laighton Thaxter (1835–1894) look for a literary tradition in which she could create a writer's life on the New England coast in mid-nineteenth-century America? No other young American woman had been raised in the isolation of a lighthouse, then privately tutored in her own island home by a brilliant young literary scholar and law student, Levi Thaxter (1824–1884). From the sea came tales of adventure and discovery, while from the seas of the classic literature came the mythic traditions of the Western world. How does the young female mind energize itself with epics of the birth of nations and heroic exploits of men in search of conquest? Then, looking forward, how does that young woman assimilate the language of a country moving inevitably toward the chaos of a Civil War, a country where women had few legal rights and even fewer models of women living the intellectual life toward which her natural talents compelled her?

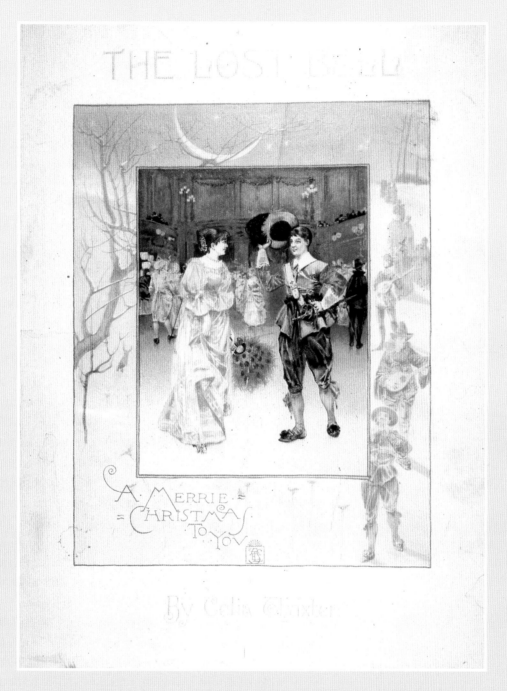

The Lost Bell *by Celia Thaxter, n.d., illustrated by Childe Hassam, Christmas publication, n.d. Courtesy Bill and Sharon Stephan.*

Celia Thaxter inherited the romantic forms of an earlier generation that she then infused with her own voice to create the new American realism that her generation of readers and writers demanded. Later in her life, painting and music would be her artistic focus, but for Celia Thaxter, in the beginning, it was the words. Let us trace her aesthetic development in a brief attempt to understand what T.S. Eliot later theorized in his essay "Tradition and the Individual Talent." That is, every artist must come to terms with the interface between her cultural legacy and her own unique, emerging voice.

Placing Celia Thaxter in the literary landscape of her time can be done easily from the biographical perspective. Put simply, she knew personally almost all the great American writers of two generations. The Transcendentalists, led by Emerson, were the friends, relatives, and colleagues of Levi Thaxter, Boston Brahmin that he was. Her marriage to Levi Lincoln Thaxter in 1851 gave her entrance to the intellectual and publishing world, centered in Boston. Not only had she read Emerson, but she had dined with him as well. Hawthorne visited Celia and Levi at their home at the Isles of Shoals. Thoreau was a naturalist not unlike Levi Thaxter, and Thomas Wentworth Higginson, later to become Emily Dickinson's "preceptor," was her husband's cousin and college roommate. Before the publishing industry moved to New York in 1872, Celia and Levi knew virtually all the editors and publishers of what was then the American national literature—the writing of New Englanders. We can compare her to her contemporary romantics in traditional Boston as well as to such realists as Mark Twain and Sarah Orne Jewett.

The classification of writers as romantics or realists is quite frankly an artificial task because writers grow, change, and come under the influence of other artists or schools of thought. The early works of almost any writer reflect what T.S. Eliot defined as the tension between the individual literary voice and the literary

The Writings of Celia Thaxter

Letters of Celia Thaxter. Edited by her
Friends, A. F. and R. L. With four Portraits.
Beautifully printed on carefully selected paper, and
bound in two attractive styles, — (1) with gilt top, un-
cut front and bottom; (2) with uncut edges and paper
label, — each book containing the statement that it is
a copy of the First Edition. 12mo, $1.50.

An Island Garden. With twelve full-page
Illustrations and several smaller ones, in color, by
CHILDE HASSAM. In a handsome octavo volume,
very attractively bound, in green and gold, or white
and gold, after designs by Mrs. WHITMAN. 8vo, gilt
top, $4.00, *net*.

In this volume Mrs. Thaxter gives an account of that lovely
bit of ground on Appledore, the largest of the Isles of Shoals,
which for many years has yielded its best returns to Mrs.
Thaxter's loving care. . . . Since she was a little child in
her island home, the garden on Appledore has been a king-
dom of delight to the gardener, and, after having made it
bloom for many years, she has now in a way pressed its flow-
ers and caught its perfume between the pages of a book. The
record of the summer, from April to autumn, is kept in this
volume, which is a sort of garden idyl, notable for its thorough
knowledge of flowers and seasons and birds, and also for its
very charming sentiment inspired by garden life. — *The Out-
look, New York.*

Among the Isles of Shoals. Illustrated.
18mo, $1.25.

This little book is so accurately descriptive, that the visitor
to these enchanting, if not enchanted, isles will need no other
guide. But whether the traveler goes to these isles or not, if
he has this little volume in his pocket, wherever he is he will
have a most charming companion. — *Hartford Courant.*

Poems. New Edition. 18mo, full gilt, $1.50.

They are unique in many respects. Our bleak and rocky
New England sea-coast, all the wonders of atmospherical and
sea-change, have, I think, never before been so musically and
tenderly sung about. — JOHN G. WHITTIER.

Drift-Weed. Poems. 18mo, full gilt, $1.50.

None of the poets of to-day have made so deep and sym-
pathetic a study of the shifting aspects of the sea as has Mrs.
Thaxter, and none of them have interpreted its meanings and
analogies with half her grace and subtlety. — *Boston Journal.*

The Cruise of the Mystery, and other Poems.
16mo, illuminated parchment-paper, $1.00.

Were there no such thing in existence as " The Rime of
the Ancient Mariner," we might pronounce " The Cruise of
the Mystery " one of the finest ballads in the language. It
is the strongest in the collection, though we believe that Mrs.
Thaxter's position as a poet of natural, sweetly-flowing verses,
deeply touched with human sentiment, will rest more securely
on many of the minor poems in the collection. — *Indepen-
dent, New York.*

Sold by all Booksellers. Sent, postpaid, by

HOUGHTON, MIFFLIN & CO., BOSTON.

11 EAST 17TH STREET, NEW YORK.

*The Writings of Celia Thaxter, n.d., adver-
tising flyer, Houghton, Mifflin & Co. Courtesy
Bill and Sharon Stephan.*

tradition out of which that voice emerges. Each new writer wrestles with the old forms, trying to force his or her voice into the old patterns and themes. Yet the artist or writer emerges from the tradition only when she breaks away to a degree that makes her recognizable as "new." Occasionally the new voice is so radical that it is rejected or misunderstood: Dickinson and Whitman are the best examples of such radical shifts. Only time would allow the readership to grow into the new mind-set necessary to accommodate their genius. To become accepted immediately as both Thaxter and Twain were suggests that there was an element of the familiar—the old tradition—that made them instantly comprehensible. However, their easy acceptance does not diminish their accomplishment. It may reflect nothing more than their affection for the old forms—or their need to make a living. In the end, romanticism and realism are aesthetic perspectives that bracket a continuum from subjective to objective point of view: romanticism includes such traditional themes as the supernatural, the mythical past, and the poet's highly personal experiences, while realism focuses on human agency, the unforgiving present, and the natural world.

New England did not dominate the literature of America after the Civil War. When Celia Thaxter's first poem, "Land-Locked," appeared in the *Atlantic Monthly* in March 1861, across the page there was a story from the West. It was the first supplement of Mark Twain's *Life on the Mississippi*. Although the editor, James Russell Lowell, was a part of the Thaxter social circle, Mark Twain would not meet Thaxter for another decade. Thaxter, whose early exposure to literature had included the popular Fireside Poets such as Bryant, Longfellow, Lowell, and Whittier, as well as Shakespeare and the ancients, did not appear to be a likely candidate for the school of realism that was developing all around her. Her first three poems, "Land-Locked," "Off

OPPOSITE TOP: The Coming of the Swallow, *n.d., ribbon bound publication of two Thaxter poems, Ballard Art Publishing Company, Worcester, Massachusetts. Courtesy Bill and Sharon Stephan.*

BOTTOM: *Page from* My Lighthouse, and Other Poems *written and illustrated by Celia Thaxter, 1890, L. Prang & Company. Courtesy Vaughn Cottage Memorial Library and Museum, Star Island Corporation.*

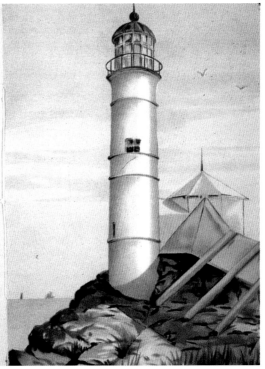

Lift up thy light, O Soul, arise and shine,
 Steadfast while all the storms of life assail!
Immortal spark of the great Light divine,
 Against whose power no tempest shall prevail!

Hold high thy lamp above earth's restless tides,
 Scatter thy messages of hope afar!
Falsehood and folly pass, but Truth abides:
 Thine be the splendor of her deathless star.

When the world's sins and sorrows round thee are
 Pierce thou the darkness with thy dauntless ray,
Send out thy happy beams to help and save,
 "More and more shining to the perfect day!"

 Celia Thaxter.

Shore," and "Expectation" were in the romantic mode that dwelt upon dreamy twilight scenes and a vague yearning for reunion with a loved one. "Off Shore," Thaxter's second poem, depicts a familiar romantic scene:

Thick falls the dew, soundless on sea and shore:
It shines on little boat and idle oar,
Wherever moonbeams touch with tranquil glow.

The waves are full of whispers wild and sweet;
They call to me,—incessantly they beat
Along the boat from stern to curve'd prow.

No sinister intent is suspected in Nature's plan, nor does the speaker fear the wind that

 . . . blows back my hair,
All damp with dew, to kiss me unaware,
Murmuring "Thee I love," and passes on.

Bound editions of popular magazines
featuring Thaxter's writing.

By the time Thaxter wrote her third poem, "Expectation," her tone had begun to undergo change, even though there is a positive resolution to the poem. The speaker awaits a boat carrying her love:

> Thou comest not! I ponder o'er the leaves,
>> The crimson drift behind the open door:
> Soon shall we listen to a wind grieves,
>> Mourning this glad year, dead forevermore.
>
> And, O my love, shall we on some sad day
>> Find joys and hopes low fallen like the leaves
> Blown by life's chilly autumn wind away
>> In withered heaps God's eye alone perceives?
>
> Come thou, and save me from my dreary thought!
>> Who dares to question Time, what it may bring?
> Yet round us lies the radiant summer, fraught
>> With beauty: must we dream of suffering?
>
> Yea, even so. Through this enchanted land,
>> This morning-red of life, we go to meet
> The tempest in the desert, hand in hand,
>> Along God's paths of pain, that seek his feet.
>
> But this one golden moment,—hold it fast!

By only the third poem, the speaker focuses not on "dream time" but on the precarious present, with its ominous crimson and morning/mourning red symbols. Gone is the romantic optimism found in the nature poetry of William Cullen Bryant a generation earlier when he assures the waterfowl that God will guide the flight of both the bird and the poet. In "Expectation" the young poet has already begun to depart from the older tradition; hence her voice becomes more individual and more clear.

Thaxter demonstrates precisely T.S. Eliot's theory of the tension between Tradition and the Individual Talent.

Within only a couple of years, the transition is complete and permanent. Thaxter's fourth poem, "The Wreck of the Pocahontas," includes a brief prayer wherein the child narrator attempts to reconcile the scene of destruction before her:

"Father in heaven," I said,—

A child's grief struggling in my breast,—
"Do purposeless thy children meet
Such bitter death? How was it best
These hearts should cease to beat?

O wherefore? Are we naught to Thee?
Like senseless weeds that rise and fall
Upon thine awful sea, are we
No more then, after all?"

This fourth out of three hundred poems serves as early evidence that Thaxter will turn a clear eye toward the sea that she has previously worshipped as a benign symbol of God's love. There is no vague yearning, but rather a rational questioning of the meaning of life.

Just because Thaxter and Twain appear face to face in the *Atlantic* does not mean a comparison should be forced between the two; however, the fact underscores several important aspects of the rise of realism in American literature. First, Thaxter and Twain were published in magazines, not books. New technology led to changes in the publishing industry so that there was room for newcomers, who usually heralded their young voices with short pieces such as poems, sketches, and short stories; often the line between the latter two was blurred. Twain and Sarah Orne Jewett could write loose narrative sketches of western mining

The Sandpiper *by Celia Thaxter , also* Sandalphon *by Henry Wadsworth Longfellow, n.d., Parker Publishing Co., Taylorville, Illinois, leaflet. Courtesy Bill and Sharon Stephan.*

camps or remote Maine coastal villages, and few readers probably knew the difference between the genres. Readers didn't care. They wanted information about the changing, growing new country with its vast spaces and cultural variety. Twain and Jewett used dialogue in the vernacular to create a unique sense of place. Thaxter used the same technique later in *Among the Isles of Shoals* even though she, herself, spoke the upper-class language of her time thanks to Levi Thaxter. The vernacular was a source of humor for most writers, and humor led to magazine sales. Thrifty New Englanders would probably not have spent their hard-earned money on humorous books.

Thaxter and Twain, unlikely couple though they were, represent a turning point in American literature in yet another way. Both used children as main characters or narrators when they wanted to escape reality: Rascally Tom Sawyer served as a parody of the romantic point of view; Thaxter's children are often obedient to the point of self-denial. The little girl running on the beach with the sandpiper couches her statement of belief in the form of a question:

> *. . . Are we not God's children both,*
> *Thou, little sandpiper, and I?*

This most famous line of Thaxter poetry has often been interpreted as being an affirmation. Read outside the context of Thaxter's complete works, it certainly can be affirmative, but read within the context of Thaxter other poetry and prose, the tone is unclear. Tiny sandpiper versus "Loosed storm . . . breaking furiously? / To what warm shelter canst thou fly?" The realist hides behind the voice of the child-like Huck Finn whistling as he walks by the graveyard. How ironic that Celia Thaxter, raised in the romantic period of American literature, turns out to be, like Twain, a realist.

The Sandpiper

Across the narrow beach we flit,
* One little sandpiper and I*
And fast I gather, bit by bit,
* The scattered driftwood bleached and dry.*
The wild waves reach their hands for it,
* The wild wind raves, the tide runs high,*
As up and down the beach we flit,—
* One little sandpiper and I.*

Above our heads the sullen clouds
* Scud black and swift across the sky;*
Like silent ghosts in misty shrouds
* Stand out the white light-houses high.*
Almost as far as eye can reach
* I see the close-reefed vessels fly,*
As fast we flit along the beach,—
* One little sandpiper and I.*

I watch him as he skims along,
* Uttering his sweet and mournful cry.*
He starts not at my fitful song,
* Or flash of fluttering drapery.*
He has no thought of any wrong;
* He scans me with a fearless eye.*
Stanch friends are we, well tried and strong,
* The little sandpiper and I.*

Comrade, where wilt thou be to-night
* When the loosed storm breaks furiously?*
My driftwood fire will burn so bright!
* To what warm shelter canst thou fly?*
I do not fear for thee, though wroth
* The tempest rushes through the sky:*
For are we not God's children both,
* Thou, little sandpiper, and I?*

Celia Laighton Thaxter, illustrated
page—sandpiper, watercolor over set
type, from Celia Thaxter, Poems, *1873.*
Courtesy Mr. and Mrs. Fred McGill.

By the 1880s Thaxter and Twain had met in Kittery, Maine, at the home of William Dean Howells, perhaps the foremost realistic fiction writer at the time. Thaxter, Twain, Howells, and even the quiet Amherst poet Emily Dickinson had grown up to the poetry of America's greatest romantic poets: Bryant, Longfellow, Lowell, Holmes, and Whittier. The new generation of American writers opened fresh territory that included not only women writers, but also journalists from across the land. The discipline of journalism demanded the facts, and thus a new literary genre developed: sketches, travelogues, vernacular humor, and, most sophisticated of all, the psychological realism of Emily Dickinson, Walt Whitman, and Robert Frost. Thaxter should be grouped primarily with the realists because of her interest in the natural world, including the human mind, and because she used the old poetic forms for new subject matter as well as creating the new forms required by the world of journalism.

Yet another way to illuminate the similarities between the works of Thaxter and Twain, is to compare the imagery and diction of her first poem, "Land-Locked," and the opening chapter of Twain's *Life on the Mississippi.* Both are monologues on the subject of loneliness, two young writers trying to determine who they are in the dark world that surrounds them. Both hear the call of nature in the form of the river flowing to the sea. Both have wished to leave behind the shore, the land, the cities where they cannot find themselves, and both sense that the journey of the writer into the psyche will be dangerous but sweet. Each writer acknowledges the beauties of life on land, yet is drawn toward the dark unknown, symbolized by water. Later, Celia Thaxter would use Twain's journalistic technique in writing her most famous book, *Among the Isles of Shoals.* (Twain's concern about the shoals underlying the mighty river is mentioned repeatedly, a reference to his early training as a cub pilot and the uncertainty about his calling as a writer.)

Celia Thaxter's commitment to realism is simply based in telling the truth of her own experience. At times nature was benevolent, at other times mercilessly cruel. While Emerson read the book of nature to determine the meaning of goodness, beauty, and truth, Thaxter studied nature on its own terms, and thus her poetry and prose usually end with an unresolved question. Twain too studied the natural world and found it "red in tooth and claw." In "The Great Blue Heron" Thaxter warns the exquisite and rare bird that a hunter is coming:

> Then I cried aloud, *"Fly, before over the sand*
> *This lord of creation arrives*
> *With his shot and his powder and gun in his hand*
> *For the spoiling of innocent lives!"*
>
>
>
> *"Now perhaps you may live and be happy,"* I said,
> *"Sail away, Beauty, fast as you can!*
> *Put the width of the earth and the breadth of the sea*
> *Betwixt you and the Being called Man."*

Only because this is a poem for children does the possibility for the heron's escape exist.

Thaxter's friend Sarah Orne Jewett took the same theme for her short story "The Great White Heron," a story in which a young girl refuses to tell the hunter where he can find the heron's nest. By keeping nature's secret, Jewett's young narrator grows up and accepts the reality of the hunter's intent. On the other hand, Twain's major character, Huck Finn never grows up—he ends his trip down the Mississippi by making plans to "light out for the territory" where he can hunt down Indians. It seems that Twain and Thaxter's boy characters never grow up, while the girl characters do. Perhaps what it means is that the greatest, most foolish, romantic perspective of all lies in seeing oneself as a "Lord of

Creation." Women in the works of both Twain and Thaxter never take on the romantically egotistic role of men, males seeking out danger and flirting with death for no purpose other than momentary dominance. The risk-taking males whom Thaxter admires are the brave fishermen and sailors, not the sportsman hunters. In both writers wisdom resides with such women as the sensible Mary Ann in *Huckleberry Finn* and the narrator kneeling at the gravestone in "In Kittery Churchyard" who states in most unromantic terms the husband's likely response to the death of his young wife:

"Doubtless he found another mate before
He followed Mary to the happy shore!"

.

And in my eyes I feel the foolish tears
For buried sorrow, dead a hundred years.

For Thaxter, the Isles of Shoals were an outpost often as remote as the "Wild West." There she studied nature in order to maintain a sense of self within the universe. Each poem she wrote, each teacup she painted, each sketch of the distant shore that she captured in watercolor became a stay against a disorderly and unpredictable world. For Thaxter, art—verbal, visual, and musical—brought order to a chaotic universe. Landscape or seascape? Both were filled with terror and unpredictability. Thaxter appropriates both sets of imagery for the development of her own voice.

There is no irony in a teacup. Its fragile shell holds civilization: tea brought at great price from China, water brought often at great labor from a distant well. Water and tea, heated together and shared with another, symbolize both our humanity and our culture. That Celia Thaxter chose to spend more time painting delicate china and pottery as the years went by suggests that she might have lost her faith in words. Words of poetry, words of prose, words of instruction—perhaps Celia came to believe that

words were incapable of holding reality. More fragile than the greenware she ordered from Boston, words reached a point beyond which they were no longer useful. But a dish—painted with a scarlet pimpernel or embellished with old roses—a dish held out the prospect of hospitality, of a warm connection, of predictable pleasure, of usefulness. A vase or bowl could hold, for the moment, the fleeting beauty of a delicate poppy or the bending sweet pea, their fragrance and form indisputable. That Celia Thaxter turned her emphasis from the verbal to the visual arts may be the strongest evidence that she was, indeed, a realist.

Jane E. Vallier

Maize, The Nation's Emblem by Celia Thaxter, 1906, Parker's Penny Classics, leaflet. Courtesy Bill and Sharon Stephan.

Paradise for a Season:
Celia Thaxter's Garden

Celia Thaxter, the renowned poet of the Isles of Shoals, was a gardener. Her unique persona as gardener was, ultimately, mythical, her garden paradisiacal. It was a Centennial garden in spirit, heady with the nostalgia that prevailed around the time of the nation's hundredth anniversary for an elysian past. The garden was lost to fire in 1914. A Bicentennial reconstruction of the original, led by Dr. John M. Kingsbury of Cornell University, made manifest a heritage of landscape history, garden literature, botanical history, and plant craft.

The golden gardening achievement of Celia Thaxter was located in front of her parents' cottage on the Isles of Shoals. By the time the cottage was hers, Thaxter had expanded the garden's size and suffused its atmosphere with the dramatic personal style of her maturity. The garden was an alluring backdrop for Thaxter's island summers, almost public in the pleasure it offered guests to her family's resort on Appledore. Many came just to see

Visitors to Celia Thaxter's re-created garden with Virginia Chisholm, 1986.

Thaxter in her picture-postcard garden. Others, friends in the arts who convened at her cottage, found the garden to be one breathtaking element in the heightened experience that Thaxter made of salon life.

This paradise of a season's duration was the subject of her book *An Island Garden*, published in 1894, the year of her death. (Thaxter died in summer when her garden was at its peak.) Curiously, she rarely mentioned her beloved cultivated flowers in her poetry and when it was finally time to write about them, Thaxter chose prose—lyrical prose that conveyed dirt process, glorious description, and fascinating details of her life. Childe Hassam's paintings illuminated this garden idyll.[1]

Thaxter was at the vanguard of American garden writers, pre-eminent in the extremely popular genre of women writers who published autobiographical garden books from the late nineteenth century until the end of World War II. An avid public awaited the personal accounts of Helena Rutherfurd Ely, Mrs. Francis King, Anna B. Warner, Louise Beebe Wilder, and others. Many of these women became prolific writers of garden books and magazine articles; Mrs. King became an editor. Thaxter's future as a garden writer was cut short by her death, but *An Island Garden* was a legacy to writers who followed, citing Thaxter in their own publications.

Alice Morse Earle quoted Thaxter in her classic book *Old Time Gardens*, 1901,[2] thereby identifying Thaxter with the faction of American gardeners who eschewed new Victorian styles for the gardens of a romantically recollected, preindustrial past. Thaxter declared that "mine is just a little old-fashioned garden..."[3] She avowed that the garden was not for show, but instead for cut flowers,[4] emphasizing utility and a design that was so traditional as to appear uncontrived. Thaxter's garden is a prime example of the Colonial Revival in American garden design, an out-of-doors network of walls, walks, and rooms in geometric

accord with the house, a realm of the freely interpreted eighteenth century.[5]

The vibrant center of Thaxter's garden nexus was a plot of raised rectangular beds and paths enclosed by a fence. This part of the garden was fifteen feet wide and spanned fifty feet at the base of her piazza. The grid of right angles was softened with foliage as the season advanced, and splendid flowers—hollyhocks, love-in-a-mist, mignonette, lilies, larkspurs, roses—intermingled in an exuberant display. The garden continued around the outside of the fence and up the vine-covered walls of the piazza, making a shady bower on the treeless island. It went on into the parlor, where Thaxter's intention was realized: Outside flowers bloomed and were gathered; inside, they were adored.[6] She arranged a metaphorical garden with masses of cut flowers for the delight of her salon.

Karl Thaxter. Celia Thaxter's garden viewed from outside the fence, Appledore Island, 1890, photograph. Courtesy Star Island Corporation, on deposit at Portsmouth Athenaeum.

A greater garden area extended without. Thaxter was an ardent naturalist and her garden incorporated views to island and sea, glimpsed through openings in the vine walls. Transitioning between the artful beauty of her civilized plot and the artless beauty of nature was a large bank that she scattered with poppy seed over the course of a month. Unweeded after May, the resultant naturalesque succession of bloom streamed gaily down the bank to the sea. When Thaxter walked in the garden in the cool of the day, she turned from this area of cultivated wildness, stepped where sweet peas ranged up the outer fence, and went through a gate back into the close order of the plot within.

OPPOSITE, TOP: *Celia Thaxter in front of her cottage, Appledore Island, c. 1889, photograph. Courtesy Star Island Corporation, on deposit Portsmouth Athenaeum.*

BOTTOM: *Celia Thaxter's garden with gate, Appledore Island, 1905, photograph. Courtesy Star Island Corporation, Lyman Rutledge Collection.*

Thaxter's skill as a plantswoman was great, but the inner garden was comparatively small and required a controlled economy of space. Plants had places: The errant self-sown seedlings of sweet rocket were transplanted to the corners, asters were lined along the edges of beds, combinations of verbenas and wallflowers were calculated for continuous color. Even in the burgeoning procession of bloom that ensued, Thaxter could not spare any detail and used a pocket magnifying glass in situ.

An attitude of preservation, exchange, and exploration guided Thaxter's plant selection. She said she loved the flowers that grandmothers loved,[7] self-sown annuals that sprang anew through the years and long-lived perennials from ancient rootstock. Her precious Tuscany rose was dug from a venerable garden that had since vanished. The rose, preserved in her garden and in her prose, was "a warm red, less crimson than scarlet, glowing with a kind of smoldering splendor. . . ."[8] She exchanged plants and cuttings with neighbors and friends such as writer Sarah Orne Jewett. Thaxter, famous poet-gardener, also received gifts—Mexican morning-glories and white forget-me-nots— sent by unknown friends, admirers.[9]

Thaxter shared the passion of nineteenth-century plant-hunters and hybridizers. Her planting schemes changed from season to season to accommodate new plants. Where there was room for only one old-time peony, she made space for ten tubs of exotic water plants, including the great pink lotus of Egypt and the purple lily of Zanzibar. She shopped the seed catalogs for new varieties; indeed, almost all that she planted in the fenced garden was offered by seed companies such as Burpee and Dreer in 1893.[10]

There was trouble in Eden when Thaxter's plants were threatened. The patient, loving gardener intervened like an avenging angel when slugs attacked, using salt, lime, and toads for destruction. Painful sacrifice halted the advance of the dodder

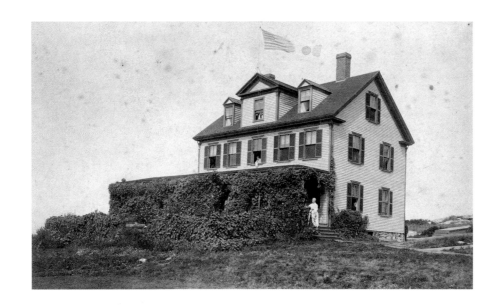

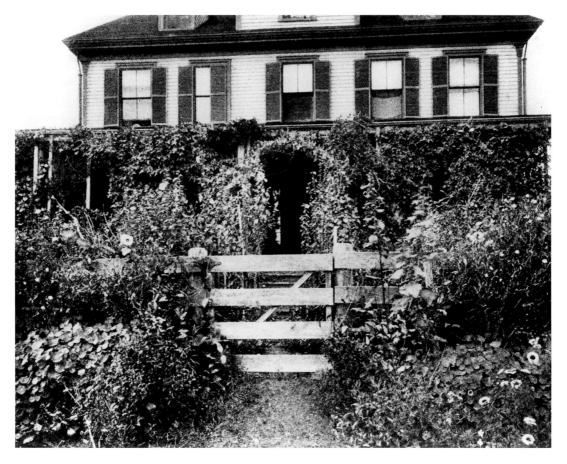

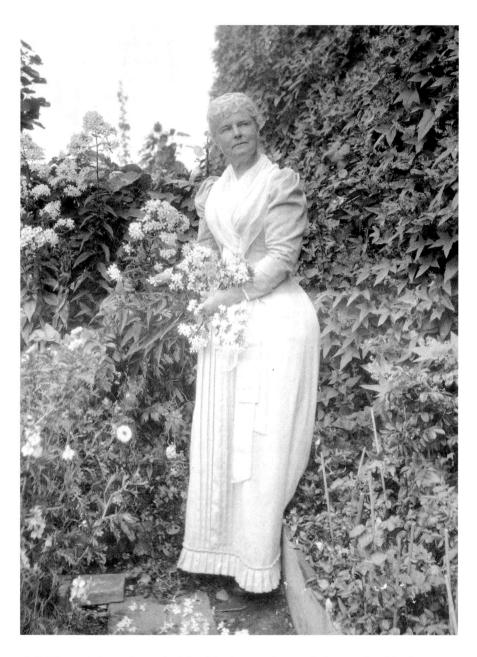

Celia Thaxter in her garden on Appledore Island, 1887, photograph. Courtesy Star Island Corporation, on deposit at Portsmouth Athenaeum.

weed; infiltrated plants had to be torn out. The exquisite artifice she imposed was defended until a dynamic balance that favored her flowers was struck in the latter part of the season.

"Now is the garden at high tide of beauty,"[11] read Thaxter's August section in *An Island Garden*. The garden's development—probably marked by everyone on the island—reached its zenith: Verdure made it to the tops of the arch and the wire supports; tall plants soared into the third dimension, a thrilling characteristic of Thaxter's garden. Slowly maturing annuals finally burst with color and fragrance. Inside the fence and outside, the garden was good.

A peaceable kingdom was established, a harmony of flora and fauna that moved its human occupants to reflection and creative expression. Thaxter painted flowers and thought about the connectedness of living things. She wondered about the humming-birds that flew over vast stretches of ocean to her flowers—more-over to her, for they landed on her person.

In the last pages of *An Island Garden*, the gardener's busy rounds were interrupted. Thaxter (imagine her white hair, white dress) stood like an archetypal figure on the liminal poppy bank after a storm. A stunned hummingbird was spotted in the plant wreckage. She picked it up and restored it to liveliness within her secure enclosed garden. Then Celia Thaxter walked up and down the garden paths—trailing birds, bees, butterflies, and flowers—like Eve triumphant in her own special paradise.

Nancy Mayer Wetzel

An Island Garden *by Celia Thaxter, 1894, cover design by Sarah Wyman Whitman, Houghton, Mifflin & Co. Courtesy Bill and Sharon Stephan.*

1. See Celia Thaxter, *An Island Garden* (Ithaca, NY: Bullbrier Press, 1985) for a reprint of the 1894 edition with a description of the reconstructed garden as it was on the 150th anniversary of Thaxter's birth.

2. Alice Morse Earle, *Old Time Gardens* (New York: The Macmillan Company, 1901), 311.

3. Thaxter, *An Island Garden*, 71.

4. Maud Appleton McDowell in Oscar Laighton, ed., *The Heavenly Guest, with Other Unpublished Writings* (Andover, MA: Oscar Laighton, 1935), 126.

5. See May Brawley Hill, *Grandmother's Garden: The Old-fashioned American Garden, 1865–1915* (New York: Harry N. Abrams, Inc., 1995) for more on this period of landscape history and garden literature.

6. Thaxter, *An Island Garden*, 102.

7. Thaxter, *An Island Garden*, 44.

8. Thaxter, *An Island Garden*, 53.

9. I am grateful to Virginia Chisholm, head gardener at the re-created site, for her insight on Thaxter's garden as a Friendship Garden.

10. Joanna M. Kingsbury, "The Identity and Source of Plants Celia Thaxter Grew in her Garden"; honors paper, Colgate University, 1979.

11. Thaxter, *An Island Garden*, 117.

Dust

Here is a problem, a wonder for all to see.
Look at this marvelous thing I hold in my hand!
This is a magic surprising, a mystery
Strange as a miracle, harder to understand.

What is it? Only a handful of earth: to your touch
A dry rough powder you trample beneath your feet,
Dark and lifeless; but think for a moment, how much
It hides and holds that is beautiful, bitter, or sweet.

Think of the glory of color! The red of the rose,
Green of the myriad leaves and the fields of grass,
Yellow as bright as the sun where the daffodil blows,
Purple where violets nod as the breezes pass.

Think of the manifold form, of the oak and the vine,
Nut, and fruit, and cluster, and ears of corn;
Of the anchored water-lily, a thing divine,
Unfolding its dazzling snow to the kiss of morn.

Think of the delicate perfumes borne on the gale,
Of the golden willow catkin's odor of spring,
Of the breath of the rich narcissus waxen-pale,
Of the sweet pea's flight of flowers, of the nettle's sting.

Strange that this lifeless thing gives vine, flower, tree,
Color and shape and character, fragrance too;
That the timber that builds the house, the ship for the sea,
Out of this powder its strength and its toughness drew!

That the cocoa among the palms should suck its milk
From this dry dust, while dates from the self-same soil
Summon their sweet rich fruit: that our shining silk
The mulberry leaves should yield to the worm's slow toil.

How should the poppy steal sleep from the very source
That grants to the grapevine juice that can madden or cheer?
How does the weed find food for its fabric coarse
Where the lilies proud their blossoms pure uprear?

Who shall compass or fathom God's thought profound?
We can but praise, for we may not understand;
But there's no more beautiful riddle the whole world round
Than is hid in this heap of dust I hold in my hand.

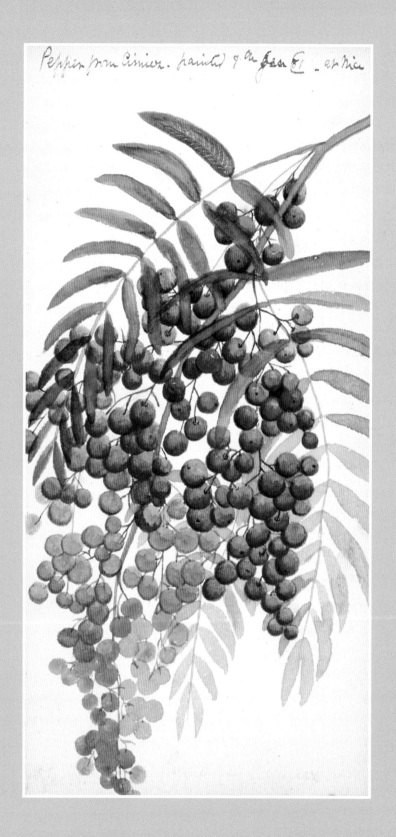

Pepper from Cimiez. painted 9th Jan 81 — at Nice

One Woman's Work

The Visual Art of Celia Laighton Thaxter

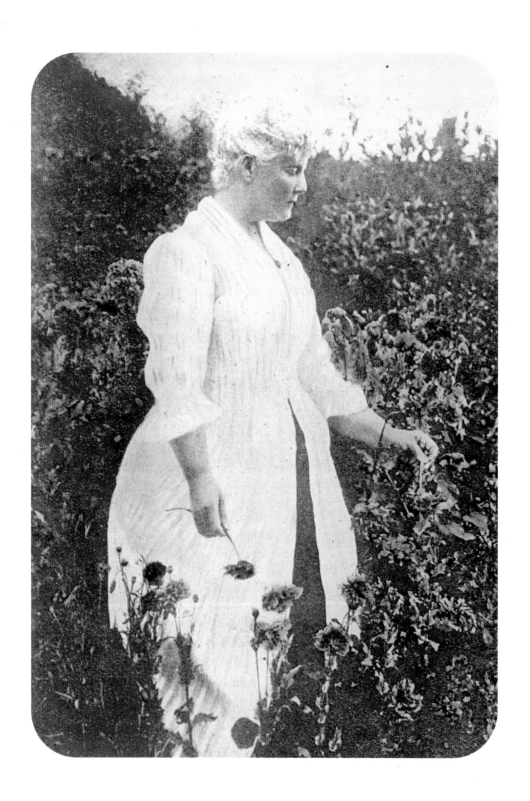

D aughter of New Hampshire and hostess to one of America's first artists' colonies, Celia Laighton Thaxter was a renaissance woman working within the confines of Victorian New England. The bleak gray rocks of her home on the Isles of Shoals, straddling the coasts of New Hampshire and Maine, provided a blank canvas for the development of her colorful artistry. A child of nature with exceptional powers of observation, Thaxter recognized the unmatched beauty of the universe and found inspiration and expression in her harsh, isolated environment. She developed a passion for the plants and tiny creatures sharing her island home, and the barren island of Appledore proved fertile ground for her growth as a visual artist.

OPPOSITE: *Celia Thaxter in her garden, c. 1890, hand-tinted lantern slide. Courtesy Portsmouth Athenaeum.*

ABOVE: *Celia Thaxter's parlor, c. 1890, hand-tinted lantern slide. Courtesy Portsmouth Athenaeum.*

PRECEDING PAGE: *Celia Laighton Thaxter, sketchbook—pepperberry* (Schinus molle), *watercolor. Courtesy Celia Thaxter Hubbard.*

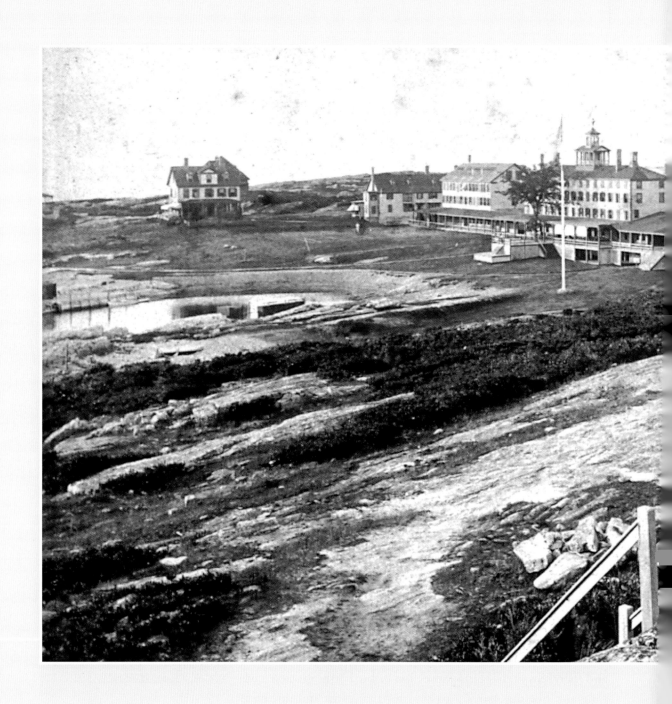

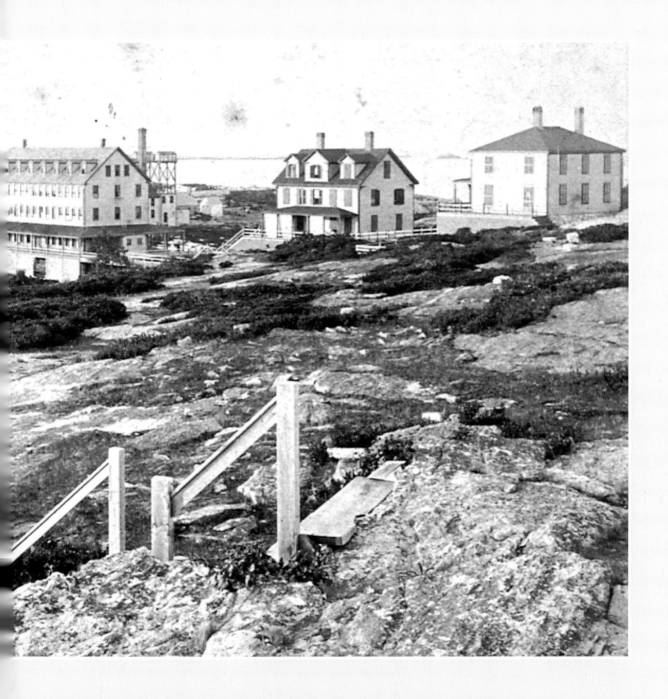

"*Upon Appledore a large house of entertainment has been extending its capabilities for many years.*"

—CELIA LAIGHTON THAXTER

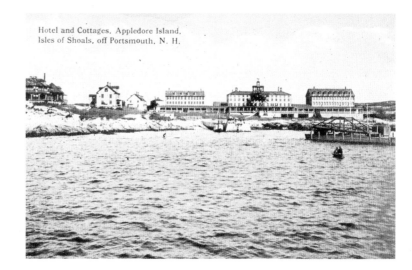

Hotel and Cottages, Appledore Island,
Isles of Shoals, off Portsmouth, N. H.

*Hotel and Cottages, Appledore Island,
Isles-of-Shoals, off Portsmouth, N.H.,
penny postcard. Courtesy Bill and Sharon
Stephan.*

OPPOSITE, TOP: *Celia Thaxter Cottage,
Isles-of-Shoals, N.H., c. 1890s, penny
postcard. Courtesy Bill and Sharon
Stephan.*

BOTTOM: *Karl Thaxter. Celia Thaxter
and friends on her piazza, c. 1887,
left to right: Mrs. Hepworth, Amy L.
Stoddard, Miss Charlotte Dana, Mrs.
Childe Hassam, Mary G. Stoddard,
Celia Thaxter, Childe Hassam, photo-
graph. Courtesy University of New
Hampshire, Instructional Services, The
New Hampshire Collection.*

PRECEDING PAGE: *Appledore House
and cottages, n.d., photograph. Courtesy
Bill and Sharon Stephan.*

Thaxter lived before modern entertainment media, when poetry was popular and poets, writers, and musicians were widely revered as celebrities. In the late 1800s and well into the first decade of the twentieth century, before the advent of art galleries, an artist's studio was a place to work, socialize, and promote art. Thaxter's home on Appledore Island provided just such a sanctuary for the colorful worlds of music, literature, and art. Located adjacent to the resort hotel her family established, her cottage parlor was a retreat, summer workplace, and noted cultural salon for Boston's preeminent literary and artistic circles.[1] Lovell Thompson wrote,

> *Under the circumstances the world could not beat a path to Mrs. Thaxter's door; but you may imagine a groove in the Atlantic left there by the prows of many voyages made by distinguished literary men, among them Whittier, Thomas Wentworth Higginson, James Whitcomb Riley and James Russell Lowell. In one of his* American Notebooks Hawthorne *wrote: "At about ten o'clock, Mr. Titcomb and myself took leave; and emerging into the open air, out of that room of song and pretty youthfulness of woman, and gay young men, there was the sky, and the three-quarters waning moon, and the old sea moaning all around the island."*[2]

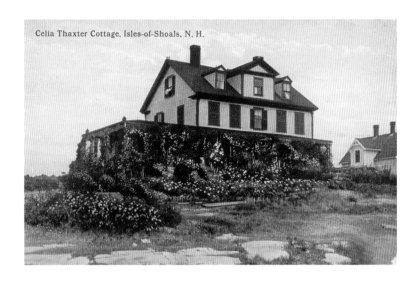

Celia Thaxter Cottage, Isles-of-Shoals, N. H.

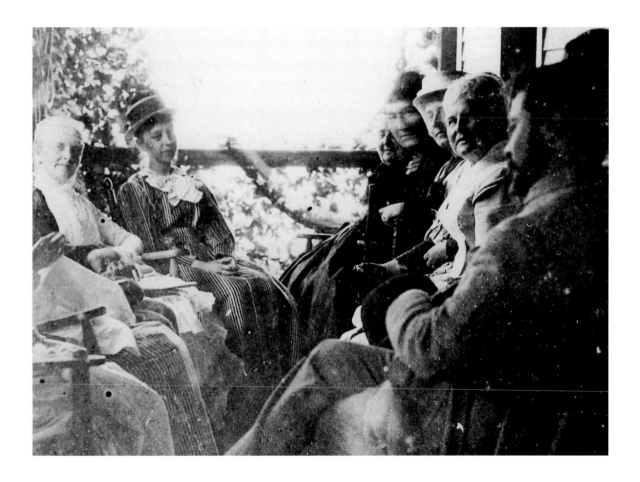

Celia Laighton Thaxter, plate with poppy (Papaver), *1879, earthenware. Courtesy Vaughn Cottage Memorial Library and Museum, Star Island Corporation.*

BELOW: *Poppy* (Papaver) *in Celia Thaxter's re-created garden, Appledore Island.*

OPPOSITE: *Celia Laighton Thaxter, illustrated page—poppy* (Papaver), *watercolor over set type, from Celia Thaxter,* The Cruise of the Mystery, and Other Poems, *1886. Courtesy Donna Marion Titus.*

Thaxter was not only host of this salon; she was also a literary celebrity in her own right. Her poetry and prose, often depicting the landscape and plant life of Appledore, were published in all the popular magazines of the day.[3] A respected American garden writer[4] who was also included in literary anthologies and featured in school readers, Thaxter was studied by adults and children alike. Her popularity ensured her success as a nineteenth-century writer, yet Thaxter chose to venture beyond this early achievement with the written word by exploring additional forms of artistic expression.

"But the poppy is painted glass;
it never glows so brightly as when the sun shines through it."

—CELIA LAIGHTON THAXTER

SCHUMANN'S SONATA IN A MINOR.

(MIT LEIDENSCHAFTLICHEM AUSDRUCK.)

THE quiet room, the flowers, the perfumed calm,
 The slender crystal vase, where all aflame
The scarlet poppies stand erect and tall,
 Color that burns as if no frost could tame,
The shaded lamplight glowing over all,
 The summer night a dream of warmth and
 balm.

Outbreaks at once the golden melody,
 "With passionate expression!" Ah, from
 whence
Comes the enchantment of this potent spell,
 This charm that takes us captive, soul and
 sense?
The sacred power of music, who shall tell,
 Who find the secret of its mastery?

Because women writers of the nineteenth century were not paid well in spite of their creativity and popularity with readers, Thaxter, motivated in part by financial pressures, turned to painting for new direction and inspiration. Her overwhelming focus was nature. Her imagination took strength from the rocks, shells, sea moss, and flowers. By capturing nature on paper and ceramics, she was able to support her family and grow as a visual artist. Her life itself became an artistic creation.

Today, Thaxter is known for her literary work, generally categorized as regional literature, or for her tireless efforts as a flower gardener.[5] Her visual art receives little if any attention and has been far less recognized by early biographers or scholars. Even during her own life, she had been a successful writer for more than twelve years before any printed reference was made to her art. In the *Portsmouth Journal of Literature & Politics*, dated September 19, 1873, an article about her noted: "Not only is she a writer, but an artist of delicate taste. She decorated a volume of her poems in dainty fashion, painting across the pages so skillfully that they seem like pressed flowers."

ABOVE: *Bisque blanks with flowers, brushes, and books.*

Bisque blank with fresh flowers.

OPPOSITE: *Celia Laighton Thaxter, loose illustrated page—poppy* (Papaver), *watercolor over set type, from Celia Thaxter,* Poems, *n.d. Courtesy Bill and Sharon Stephan.*

SCHUBERT.

At the open window I lean,
 Flowers in the garden withou[t]
 Faint in the heat and the dr[ought]
What does the music mean?

For here, from the cold keys within,
 Is a tempest of melody drawn;
 Doubts, passionate questions, the dawn
Of high hope, and a triumph to win;

While out in the garden, blood-red
 The poppy droops, faint in the heat
 Of the noon, and the sea-wind so sweet
Caresses its delicate head.

And still the strong music goes on
 With its storming of beautiful heights,
 With its sorrow that heaven requites,
And the victory fought for is won!

Thaxter's life was spent exploring many avenues of expression, and it was her work with the visual arts, rather than her writing, that became her greatest source of personal pleasure and fulfillment. Painting china, illustrating books, tending her garden, and creating a salon environment were essential to this woman, who found that "expression became a necessity."[6] All of Thaxter's activities were linked by her passion for nature in its basic simplicity. From the smallest pimpernel to panoramic seascapes, her visual art featured the Isles prominently. As she transcribed her subjects onto useful everyday items such as plates, bowls, and greeting cards, they became wondrous works of art.

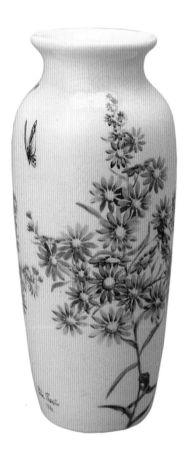

Celia Laighton Thaxter, vase with aster (Aster) *and butterflies, 1880, earthenware. Courtesy Vaughn Cottage Memorial Library and Museum, Star Island Corporation.*

OPPOSITE: *Asters* (Aster) *in Celia Thaxter's re-created garden, Appledore Island.*

"Ever since I could remember anything,
flowers have been like dear friends to me. . ."
—Celia Laighton Thaxter

Thaxter sought her own unique style when she entered the realm of visual art. Studying painting with artists Ross Sterling Turner, J. Appleton Brown, William Morris Hunt, and Childe Hassam, she developed an independent attitude and approach. Although inspired by the genius of those who frequented her home, she was not unduly influenced by them. She viewed the world with uncompromising reality and rejected the discontinuous strokes of the Impressionist movement so popular with many of her peers. Harboring no illusions of grandeur, Thaxter was a nature writer and a naturalist painter.

William Dean Howells wrote in his book *Literary Friends and Acquaintance:*

> It is interesting to remember how closely she kept to her native field, and it is wonderful to consider how richly she made those sea-beaten rocks to blossom. Something strangely full and bright came to her verse from the mystical environment of the ocean, like the luxury of leaf and tint that it gave the narrower flower-plots of her native isles. Her gift, indeed, could not satisfy itself with the terms of one art alone, however varied, and she learned to express in color the thoughts and feelings impatient of the pallor of words.[7]

Celia Laighton Thaxter, plate with aster (Aster), *1881, porcelain. Courtesy Vaughn Cottage Memorial Library and Museum, Star Island Corporation.*

OPPOSITE: *Celia Laighton Thaxter, illustrated page—aster* (Aster), *watercolor over set type, from Celia Thaxter,* Poems, *1882. Courtesy Bill and Sharon Stephan.*

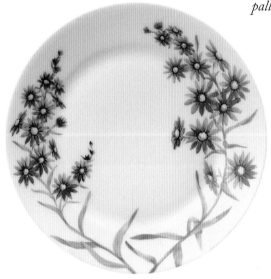

Later, June bids the sweet wild rose to blow,
 Wakes from its dream the drowsy pimpernel ;
Unfolds the bindweed's ivory buds that glow
 As delicately blushing as a shell.

Then purple Iris smiles, and hour by hour,
 The fair procession multiplies ; and soon,
In clusters creamy white, the elder-flower
 Waves its broad disk against the rising moon.

O'er quiet beaches shelving to the sea
 Tall mulleins sway, and thistles ; all day long
Flows in the wooing water dreamily,
 With subtile music in its slumberous song.

Herb-robert hears, and princess'-feather bright,
 And gold-thread clasps the little skull-cap blue ;
And troops of swallows, gathering for their flight,
 O'er goldenrod and asters hold review.

The barren island dreams in flowers, while blow
 The south winds, drawing haze o'er sea and
 land ;
Yet the great heart of ocean, throbbing slow,
 Makes the frail blossoms vibrate where they
 stand ;

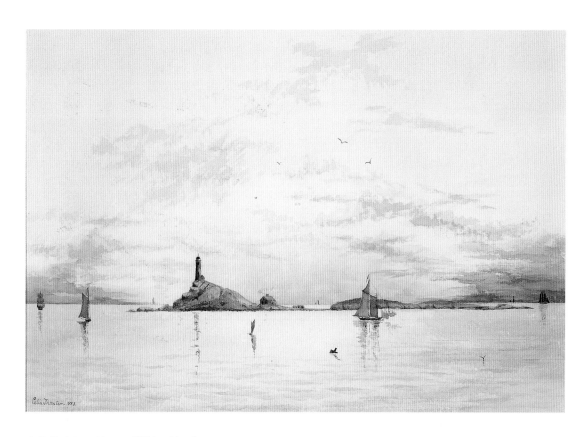

Celia Laighton Thaxter, White Island
Lighthouse, *1883, watercolor.*
Courtesy Celia Thaxter Hubbard.

Off Shore

Rock, little boat, beneath the quiet sky,
Only the stars behold us where we lie,—
Only the stars and yonder brightening moon.

On the wide sea to-night alone are we;
The sweet, bright summer day dies silently,
Its glowing sunset will have faded soon.

Rock softly, little boat, the while I mark
The far off gliding sails, distinct and dark,
Across the west pass steadily and slow.

But on the eastern waters sad, they change
And vanish, dream-like, gray, and cold, and strange
And no one knoweth whither they may go.

We care not, we, drifting with wind and tide,
While glad waves darken upon either side,
Save where the moon sends silver sparkles down.

And yonder slender stream of changing light,
Now white, now crimson, tremulously bright,
Where dark the light-house stands, with fiery crown.

Thick falls the dew, soundless on sea and shore:
It shines on little boat and idle oar,
Wherever moonbeams touch with tranquil glow.

The waves are full of whispers wild and sweet;
They call to me, —incessantly they beat
Along the boat from stern to curved prow.

Comes the careering wind, blows back my hair,
All damp with dew, to kiss me unaware,
Murmuring "Thee I love," and passes on.

Sweet sounds on rocky shores the distant rote;
Oh could we float forever, little boat,
Under the blissful sky drifting alone!

OFF SHORE.

ROCK, little boat, beneath the quiet sky,
Only the stars behold us where we lie, —
Only the stars and yonder brightening moon

On the wide sea to-night alone are we ;
The sweet, bright summer day dies silently,
Its glowing sunset will have faded soon.

Rock softly, little boat, the while I mark
The far off gliding sails, distinct and dark,
Across the west pass steadily and slow.

But on the eastern waters sad, they change
And vanish, dream-like, gray, and cold, and strange
And no one knoweth whither they may go.

We care not, we, drifting with wind and tide,
While glad waves darken upon either side,
Save where the moon sends silver sparkles down.

Celia Laighton Thaxter, illustrated
page—seascape, watercolor over set type,
from Celia Thaxter, Poems, *1891.*
Courtesy Bill and Sharon Stephan.

Celia Laighton Thaxter, Lunging Island Panorama, *watercolor. Courtesy Celia Thaxter descendant.*

Celia Laighton Thaxter, cup and saucer with violet (Viola), butterfly handle, 1888, 1881, porcelain. Courtesy Vaughn Cottage Memorial Library and Museum, Star Island Corporation.

Celia Laighton Thaxter, pitcher with violet (Viola), 1882, porcelain. Courtesy Portsmouth Athenaeum

OPPOSITE: *Celia Laighton Thaxter, sketchbook—violets (Viola), watercolor. Courtesy Portsmouth Athenaeum.*

Thus Thaxter not only exploited the "mystical" appeal of the Shoals in her writing, but also did the same with her visual art. Conditioned by the isolated barrenness of her childhood home, she directed her attention primarily to the exquisite details of blossoms, birds, butterflies, shells, and seaweed. She carried a magnifying glass with her to view "the wonders and splendors of creation." She was a realist, a visual artist painting glorious flowers and sea moss without distortion or stylization. Working with watercolors on paper and mineral paints on white china blanks, her style approached botanical precision.[8]

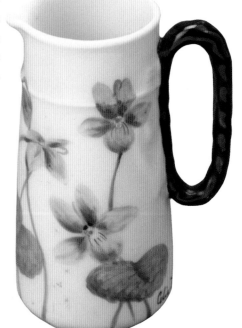

"…it is one of the wisest things in the world to carry in one's pocket a little magnifying glass, for this opens so many unknown gates into the wonders and splendors of Creation."

—CELIA LAIGHTON THAXTER

In keeping with her straightforward and naturalistic technique, Thaxter chose functional mediums. She painted useful and affordable objects. Vases, dishes, tiles, buttons, and even book illustrations served her purposes. In contrast, she produced only a few watercolors, mostly seascapes. Although she admired and valued the paintings created by her guests, it is as if producing a piece of art that would merely hang on the wall was less than fulfilling.

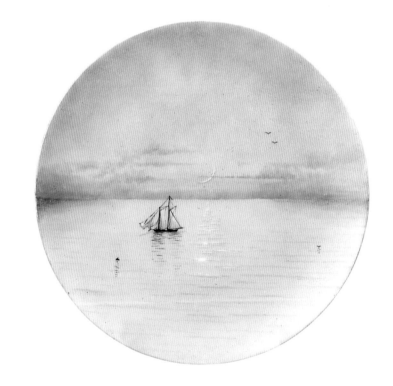

Celia Laighton Thaxter, plate with sunset, 1879, porcelain. Courtesy Strawbery Banke Museum.

FOLLOWING PAGES, CLOCKWISE FROM TOP LEFT: *Celia Laighton Thaxter,* White Island Lighthouse *(detail), watercolor. Courtesy Margaret V. H. Hubbard.*

Celia Laighton Thaxter, Seapoint Beach, *watercolor, Courtesy Celia Thaxter descendant.*

Celia Laighton Thaxter, Champernowne Farm and Elm, *1884, watercolor. Courtesy Celia Thaxter descendant.*

Celia Laighton Thaxter, Field of Gold Flowers, City Towers, *watercolor. Courtesy Martha DeNormandie.*

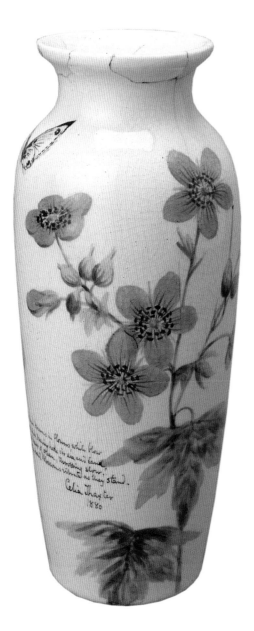

Celia Laighton Thaxter, vase with
anemone (Anemone), 1880, earthen-
ware. Courtesy Strawbery Banke
Museum.

The barren island dreams in flowers, while blow
　　The south winds, drawing haze or'e sea and land,
Yet the great heart of ocean, throbbing slow
　　Makes the frail blossoms vibrate as they stand.

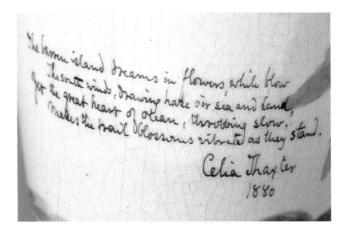

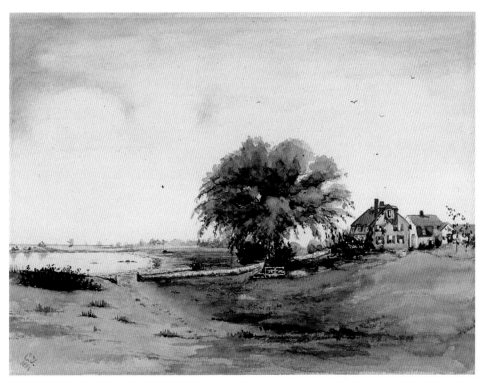

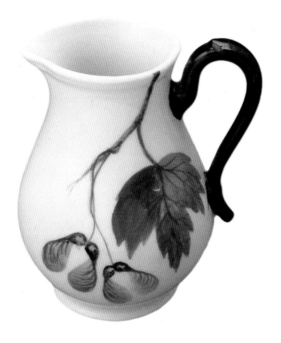

Celia Laighton Thaxter, pitcher with maple leaf (Acer) and fruit, 1878, porcelain. Courtesy Bruce and Carole Parsons.

OPPOSITE: Celia Laighton Thaxter, vase with daffodil (Narcissus), 1882, earthenware. Courtesy Strawbery Banke Museum.

Thaxter experienced a powerful self-confidence when painting these useful objects, and free from the nagging insecurity felt when writing, she enjoyed the complete process. In a letter dated September 22, 1874, she communicated her sense of excitement to Feroline Fox, writing,

> Did Carry tell you I have taken to painting,—"wrastling with art," I call it in the wildest manner? This woodbine leaf at the top of the page of this note I copied from nature. Of course it isn't very good, but it shows hope of better things, don't you think so? Do say you do! I can scarcely think of anything else. I want to paint everything I see; every leaf, stem, seed vessel, grass blade, rush, and reed and flower has new charms, and I thought I knew them all before. Such a new world opens, for I feel it in me; I know I can do it, and I am going to do it! What a resource for the dreary winter days to come! I know you will be glad for me.[9]

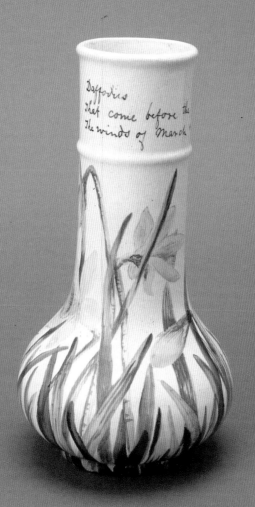

"*Daffodils*
That come before the swallow dares, and take
The winds of March with beauty."

The Winter's Tale

Celia Laighton Thaxter, sketchbook—elm leaves (Ulmus americana), *watercolor. Courtesy Celia Thaxter Hubbard.*

Celia Laighton Thaxter, illustrated page—elm leaf (Ulmus americana), *watercolor over set type, from Celia Thaxter,* Poems, *1874. Courtesy Portsmouth Athenaeum.*

TWILIGHT.

SEPTEMBER's slender crescent grows again
 Distinct in yonder peaceful evening red,
 Clearer the stars are sparkling overhead,
And all the sky is pure, without a stain.

Cool blows the evening wind from out the West
 And bows the flowers, the last sweet flowers that
 bloom,
 Pale asters, many a heavy-waving plume
Of golden-rod that bends as if opprest.

The summer's songs are hushed. Up the lone shore
 The weary waves wash sadly, and a grief
 Sounds in the wind, like farewells fond and brief:
The cricket's chirp but makes the silence more.

Life's autumn comes; the leaves begin to fall;
 The moods of spring and summer pass away;
 The glory and the rapture, day by day,
Depart, and soon the quiet grave folds all.

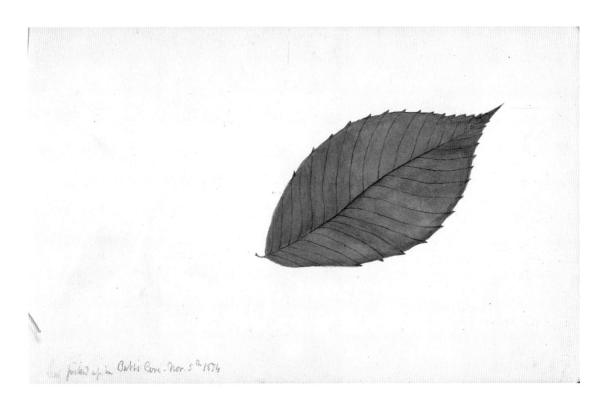

picked up in Batts Cove. Nov. 5ᵗʰ 1874

Shoals.
Dec. 17ᵗʰ 1874.

Dear Grandfather:

I found this elm leaf of rusted gold in the street, in quiet, quaint old Portsmouth on my way home. It is as like as I could make it. It takes me a long time to get White Island ready! I make so many pictures, & none of them suit me.

I think I did not thank you half enough for the address you sent, & for your delightful note about it. I read Tyndall's address twice over! & yours also with supreme satisfaction! Will he read what you have said? He ought to see it. What a joy to find himself so understood & appreciated! I have been extremely interested in Professor Huxley's address before the British Association, which I have in the Living Age. There is nothing so interesting to me as this gnawing of bright minds, this digging at the roots of things. "Your little hatchet";- O grandfather! what a weapon! Sharp, sharp, invisible, resistless. It is like a scythe, as Mr

Celia Laighton Thaxter, sketchbook—beech leaf (Fagus grandifolia), *watercolor. Courtesy Celia Thaxter Hubbard.*

Celia Laighton Thaxter, illustrated letter—elm leaf (Ulmus americana), *correspondence to Rev. John Weiss, 1874, watercolor. Courtesy Colby College, Miller Library, Special Collections.*

Her obsession with painting can also be seen in this excerpt
from a letter to Dr. Richard H. Derby written from Appledore
during a hurricane on December 11, 1876:

> *So the hurricane had a fine time careening through the
> house. I wanted a book at the cottage. Nobody could ven-
> ture for it till today, when the wind has lulled a little. It
> might as well have been in Portsmouth for all the good it
> did me. Think what it must be to live for five days in the
> centre of such an insane tumult! But I haven't thought of
> it, busied in my writing-desk and paint-box. I am paint-
> ing on china now. It is most exquisite work, fit for the
> fairies.*[10]

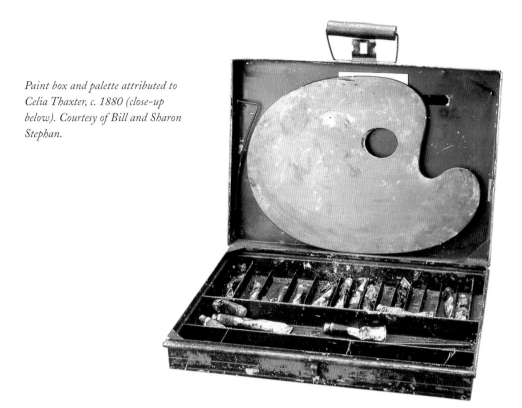

Paint box and palette attributed to Celia Thaxter, c. 1880 (close-up below). Courtesy of Bill and Sharon Stephan.

The raging Atlantic couldn't distract Thaxter from her painting, yet she frequently struggled over the lines of a poem or a piece of prose. She writes to Annie Fields, "When I have earned enough to keep me through the summer I shall stop this fever of scribbling—foolishness it is, I think, ever to force one's own pen to do anything."[11] Therefore, while she continued to both paint and write, painting was the form of expression she adored and found personally empowering. She wrote to Annie Fields in 1880, "I am so busy painting! Every minute of life . . ."[12]

Thaxter kept sketchbooks in order to capture choice bits of nature from her island home. While traveling throughout England, France, and Italy, she kept an exquisite record of the plant life she saw. Noting the location and date of each illustration—olives, pepperberries, anemones, irises, eucalyptuses, Spanish peppers, strawberry apples—she carefully recorded each in vivid color. In this sketchbook, she achieved the elusive translucence of the delicate flower petal. The berries and blossoms were sophisticated yet charming, with fine precise strokes that created depth and texture in a simple accurate manner. Her sketchbooks were a record of patterns and motifs that she would later use for her china painting and book illustrations. Thus, just as her painting emphasized simple, honest lines, her research was practical and methodical.

OPPOSITE LEFT: *Celia Laighton Thaxter, sketchbook—anemone* (Anemone), *watercolor. Courtesy Celia Thaxter Hubbard.*

RIGHT: *Celia Laighton Thaxter, sketchbook—anemone* (Anemone), *watercolor. Courtesy Celia Thaxter Hubbard.*

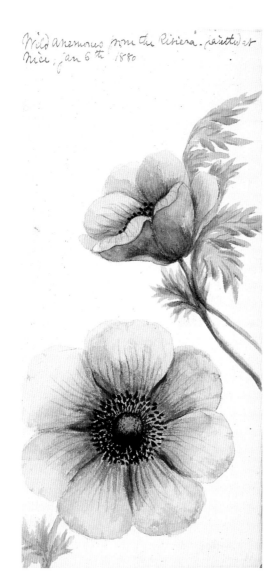

Wild anemones from the Riviera. painted at
Nice, Jan 6th 1880

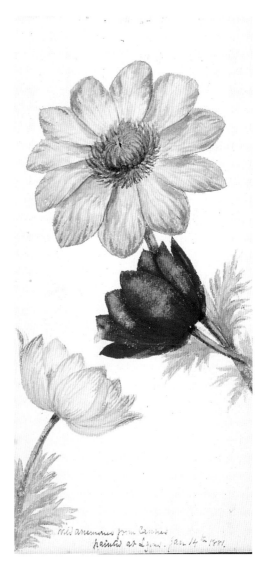

Wild anemones from Cannes
painted at Lyons. Jan 14th 1881.

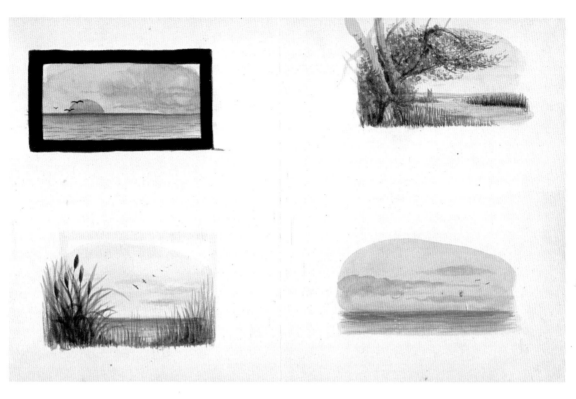

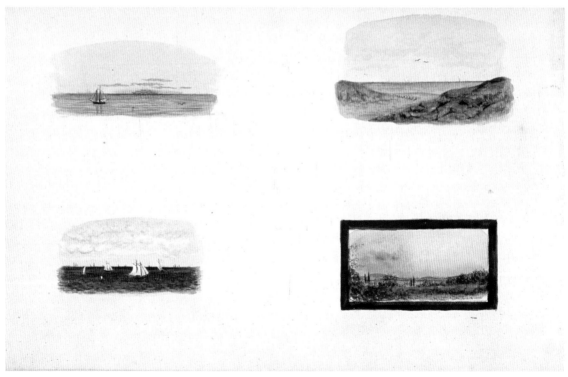

MAY MORNING.

WARM, wild, rainy wind, blowing fitfully,
Stirring dreamy breakers on the slumberous May
 sea,
What shall fail to answer thee? What thing shall
 withstand
The spell of thine enchantment, flowing over sea
 and land?

All along the swamp-edge in the rain I go;
All about my head thou the loosened locks doth
 blow;
Like the German goose-girl in the fairy tale,
I watch across the shining pool my flock of ducks
 that sail.

Redly gleam the rose-haws, dripping with the wet,
Fruit of sober autumn, glowing crimson yet;
Slender swords of iris leaves cut the water clear,
And light green creeps the tender grass, thick
 spreading far and near.

*Celia Laighton Thaxter, illustrated
page—cattails* (Typha latifolia),
*watercolor over set type, from Celia
Thaxter,* Poems, *1875. Courtesy Celia
Thaxter Hubbard.*

OPPOSITE: *Celia Laighton Thaxter,
sketchbook—vignette templates,
watercolor. Courtesy Celia Thaxter
Hubbard.*

LEFT: *Celia Laighton Thaxter, sketchbook—chokeberry* (Aronia arbutifolia), *watercolor. Courtesy Celia Thaxter Hubbard.*

RIGHT: *Celia Laighton Thaxter, sketchbook—raspberry* (Rubus idaeus), *watercolor. Courtesy Celia Thaxter Hubbard.*

LEFT: *Celia Laighton Thaxter,
sketchbook—woodbine* (Parthenocissus
quinquefolia), *watercolor. Courtesy Celia
Thaxter Hubbard.*

RIGHT: *Celia Laighton Thaxter, sketch-
book—rosehip* (Rosa virginiana), *water-
color. Courtesy Celia Thaxter Hubbard.*

THE VISUAL ART OF CELIA LAIGHTON THAXTER 125

LEFT: *Celia Laighton Thaxter, sketchbook—ligustrum* (Ligustrum japonica), *watercolor. Courtesy Celia Thaxter Hubbard.*

RIGHT: *Celia Laighton Thaxter, sketchbook—eucalyptus* (Eucalyptus), *watercolor. Courtesy Celia Thaxter Hubbard.*

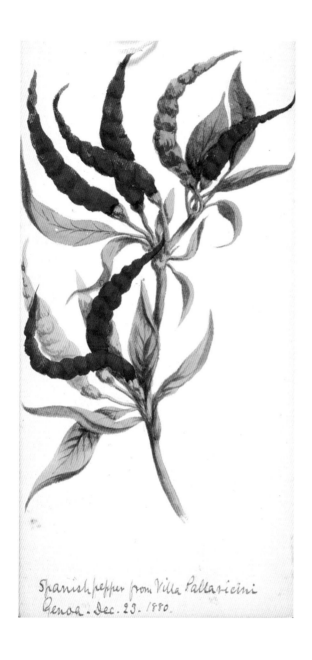

Spanish pepper from Villa Pallavicini
Genoa - Dec. 23. 1880.

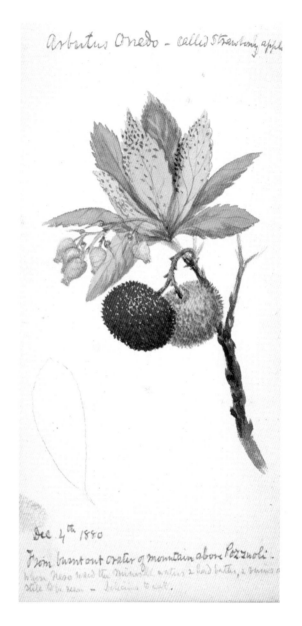

Arbutus Onedo - called strawberry apple

Dec. 4th 1880
From burnt out crater of mountain above Pozzuoli -
where Nero used the mineral waters & had baths, a ruins
still to be seen - Delicious to eat.

LEFT: *Celia Laighton Thaxter,
sketchbook—Spanish pepper* (Capsicum),
*watercolor. Courtesy Celia Thaxter
Hubbard.*

RIGHT: *Celia Laighton Thaxter,
sketchbook—strawberry apple* (Arbutus
unede), *watercolor. Courtesy Celia
Thaxter Hubbard.*

IN MAY.

THAT was a curlew calling overhead,
 That fine, clear whistle shaken from the clouds:
See! hovering o'er the swamp with wings outspread,
 He sinks where at its edge in shining crowds
The yellow violets dance as they unfold,
In the blithe spring wind, all their green and gold.

Blows South-wind, spreading bloom upon the sea,
 Drawing about the world this band of haze
So softly delicate, and bringing me
 A touch of balm that like a blessing stays;
Though beauty like a dream bathes sea and land,
For the first time Death holds me by the hand.

Yet none the less the swallows weave above
 Through the bright air a web of light and song,
And calling clear and sweet from cove to cove,
 The sandpiper, the lonely rocks among,
Makes wistful music, and the singing sea
Sends its strong chorus upward solemnly.

IN DEATH'S DESPITE.

WHITHER departs the perfume of the rose?
 Into what life dies music's golden sound?
Year after year life's long procession goes
 To hide itself beneath the senseless ground.
Upon the grave's inexorable brink
 Amazed with loss the human creature stands;
Vainly he strives to reason or to think,
 Left with his aching heart and empty
 hands;
He calls his lost in vain. In sorrow drowned,
Darkness and silence all his sense confound.

 Till in Death's roll-call stern he hears his
 name,
 In turn he follows and is lost to sight;

LEFT: *Celia Laighton Thaxter, illustrated page—yellow violets* (Viola), *watercolor over set type, from Celia Thaxter,* Poems, *1875. Courtesy Celia Thaxter Hubbard.*

RIGHT: *Celia Laighton Thaxter, illustrated page—wild rose* (Rosa virginiana), *watercolor over set type, from Celia Thaxter,* The Cruise of the Mystery, and Other Poems, *1886. Courtesy Donna Marion Titus.*

Thaxter illustrated volumes of her poetry for friends and eager customers. Flowers were her special passion. Never heavy or laden with paint or pattern, each illustrated page was a unique treasure. Thaxter embellished her poems to enhance the poetic message by carefully selecting the subject matter and its particular placement on the page. We find blossoms humbly resting among the pages where they are mentioned by name. Beyond her pleasure in painting, however, lay her recognition that the visual arts, for example, illustrations, could provide a means of financially supporting her family.[13] Thaxter embraced painting with both purpose and pleasure.

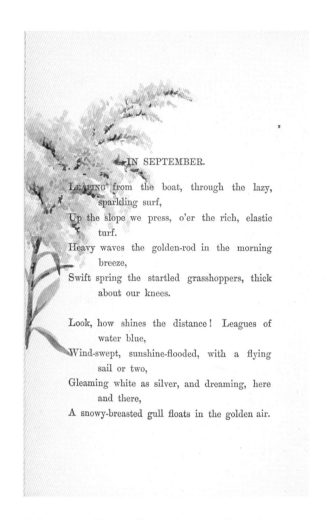

IN SEPTEMBER.

Leaping from the boat, through the lazy,
　　sparkling surf,
Up the slope we press, o'er the rich, elastic
　　turf.
Heavy waves the golden-rod in the morning
　　breeze,
Swift spring the startled grasshoppers, thick
　　about our knees.

Look, how shines the distance! Leagues of
　　water blue,
Wind-swept, sunshine-flooded, with a flying
　　sail or two,
Gleaming white as silver, and dreaming, here
　　and there,
A snowy-breasted gull floats in the golden air.

MY GARDEN.

It blossomed by the summer sea,
　　A tiny space of tangled bloom
　　Wherein so many flowers found room
A miracle it seemed to be!

Up from the ground, alert and bright,
　　The pansies laughed in gold and jet,
　　Purple and pied, and mignonette
Breathed like a spirit of delight.

Flaming the rich nasturtiums ran
　　Along the fence, and marigolds
　　"Opened afresh their starry folds"
In beauty as the day began;

While ranks of scarlet poppies gay
　　Waved when the soft south wind did blow,

Celia Laighton Thaxter, illustrated page—golden-rod, (Solidago), watercolor over set type, from Celia Thaxter, The Cruise of the Mystery, and Other Poems, *1886. Courtesy Donna Marion Titus.*

Celia Laighton Thaxter, illustrated page—pansy (Viola), *watercolor over set type, from Celia Thaxter, The Cruise of the Mystery, and Other Poems, 1886. Courtesy Donna Marion Titus.*

"And will you be kind enough to put in a word about the selection of the paper on which these are printed, that it shall be firm enough to take kindly the water-color with which I illustrate the volumes."

—Celia Laighton Thaxter

Fortunately for Thaxter, the American Aesthetic movement began to flourish due to the art and design reforms that took place in London after the Great Exposition of 1851, the expansion of trade and travel, and the powerful influences of William Morris and John Ruskin. The Philadelphia Centennial Exposition of 1876 had tremendous impact on the demand for quality and craftsmanship in the production of useful objects in the United States. In addition, the concurrent popularity of hand-painted china in the United States offered women unprecedented opportunities. As Cynthia Brandimarte explains in *Somebody's Aunt and Nobody's Mother: The American China Painter and Her Work, 1870–1920:*

> *China painting was a pastime, livelihood, and art for many American women. Most was done by the over glaze process, which involved applying mineral colors to the surface of a previously fired hard china blank, and then refiring it to a temperature that caused the enamel to fuse with the blank, making the painted design a permanent decoration.*[14]

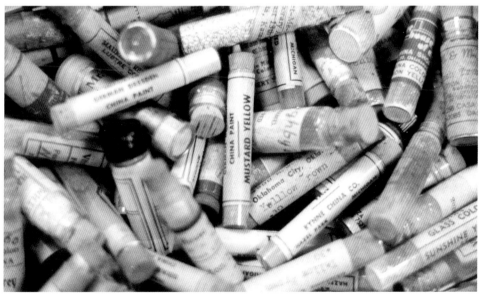

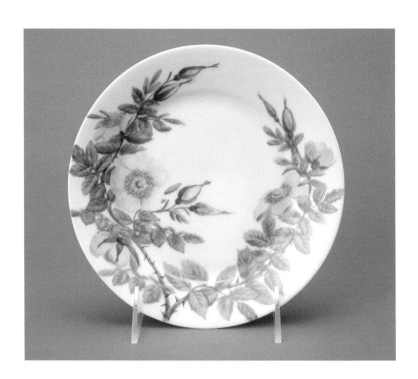

Celia Laighton Thaxter, plate with roses (Rosa virginiana), *1881, porcelain. Courtesy Vaughn Cottage Memorial Library and Museum, Star Island Corporation.*

Celia Laighton Thaxter, cup and saucer with roses (Rosa virginiana), *1881, porcelain. Courtesy Vaughn Cottage Memorial Library and Museum, Star Island Corporation.*

OPPOSITE: *Celia Laighton Thaxter, vase with roses* (Rosa virginiana), *1883, porcelain. Courtesy Celia Thaxter descendant.*

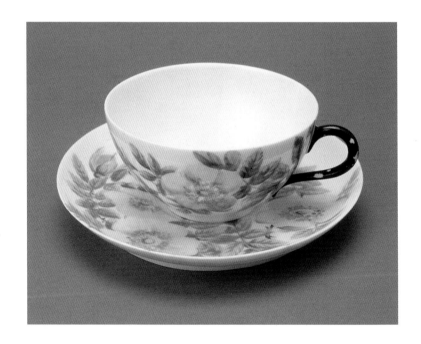

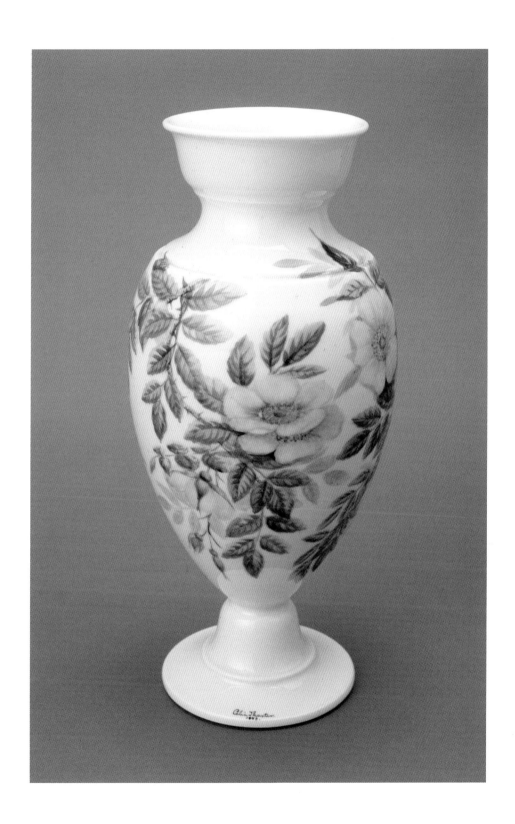

Celia Laighton Thaxter, cup and saucer with wild rose (Rosa virginiana), *butterfly handle, 1879, porcelain. Courtesy Society for the Preservation of New England Antiquities.*

Thus, Thaxter could channel her energies and talent into her china painting and capitalize on the growing demand for the aesthetically pleasing objects required for the setting of a Victorian home.

Thaxter sent her ceramic work to Cooley's in Boston, a highly respected national firm that not only provided firing services for hand-painted china, but also carried an extensive line of china blanks and supplies. On an undated postcard, she wrote to Levi Cooley, Rear 333, Charles Street, Boston, Massachusetts, directing, "I send 18 pieces for firing—kindly return just as soon as possible, I oblige. C. Thaxter. They will need very careful packing, so many in the basket."[15] In addition to selecting a prestigious kiln, Thaxter painted on European china blanks such as Haviland & Company and Wedgwood & Company. This investment proved worthwhile, as she soon turned her ceramic painting, like her book illustrations, into a livelihood.

Appledore. Sept 9th

I send 18 pieces for firing —
Kindly return just as soon
as possible, & oblige

C. Thaxter

They will need very careful packing
so many in the basket.

Correspondence from Celia Thaxter to
Levi Cooley, c. 1880, postcard, written
and signed by Celia Thaxter. Courtesy
Bill and Sharon Stephan.

POSTAL CARD.

WRITE THE ADDRESS ON THIS SIDE—THE MESSAGE ON THE OTHER

ONE CENT

Levi Cooley,
Rear 333, Charles St.
Boston, Mass.

Creating hand-painted china was far more lucrative than writing poetry or prose. The pieces were both collectible and functional, and items painted and signed by a popular personality were desired commercial objects. As a result, Thaxter was able to establish a viable means of supporting her family without sacrificing her personal joy and satisfaction. Even friend Lucy Larcom noted, "Mrs. Thaxter was at Mrs. Fields' painting China plates by the dozen; she seems to have exchanged poetry for pottery. I doubt not she finds it more profitable business . . ."[16]

Celia Laighton Thaxter, pitcher with marigold (Calendula officinalis), *1881, earthenware. Courtesy Strawbery Banke Museum.*

Correspondence from Celia Thaxter to Mrs. Aldrich, 1881. Courtesy Strawbery Banke Museum.

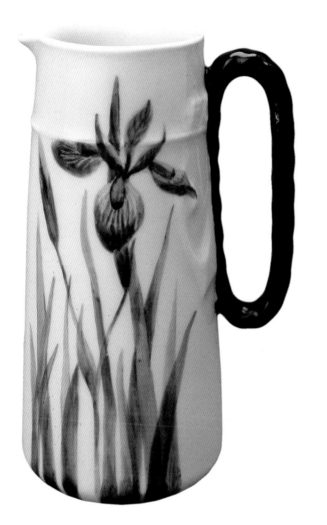

*Celia Laighton Thaxter, pitcher with iris
(Iris), 1878, porcelain. Courtesy
Prudence C. Randall.*

BELOW: *Detail of inscription on base.*

Celia Thaxter
1878.

For J. K. Paine.

The last Iris flower
of the summer of 1878.

Correspondence from Celia Thaxter to Mr. Stoddard, regarding fee for book illustrations, 1891. Courtesy University of New Hampshire, Milne Special Collections and Archives.

Shoals, Jan 25th
'91

Mr Stoddard:

Dear Sir:

I am very sorry you were prevented from coming to see me & am flattered to [?] [?] letter. About the book & painting. For the last three years I have not been well enough to paint, so that I have no work on hand, but I am beginning to grow strong once more & shall be at my painting again presently. The way in which I illustrate my books is to paint in the margins of the pages, flowers, shells, seaweeds

bits of landscape &c, — the price
of a copy so illustrated would
depend upon the number of
pictures — Ten illustrations would
be Ten dollars with photo &
Autograph, & more according
to number. I think I can
do it for [...] & send to my
permanent address a little
later, if you wish —
 Yrs truly
 C Thaxter

Here are 3 different sets of poems.
If you will [...] me which.
Of course the price of the book is separate.

Olive.
Painted at Nice, 6th Jan. 1881.

"*O, there is nothing so beautiful in its way as an olive,
so graceful, so elegant, so classic one might say.*"

—Celia Laighton Thaxter

One of Thaxter's favorite painting themes was the olive branch. In a letter to Annie Fields from Menton, France, dated December 31, 1880, she wrote, "O there is nothing so beautiful in its way as an olive, so graceful, so elegant, so classic one might say."[17] She repeated the olive branch's grace, form, and subtle color on her ceramic objects and in her illustrations. Olive branch designs were always accompanied by a Greek quote by Sophocles that she explained to Annie Fields in a letter dated November 2, 1881.

DOWN S. Miniato in the afternoon,
　Slowly we drove through still and golden
　　　air.
'T was winter, but the day was soft as
　　　June ;
　Florence was spread beneath us, passing
　　　fair.

The matchless city ! Set about with flowers,
　Peaceful along her Arno's banks she lay ;
Her treasured splendors, roofs and domes and
　　　towers,
　In tender light of the Italian day.

Sweet breathed the roses, glowing far and
　　　wide,
　Pink, gold, and crimson ; dark in stately
　　　gloom

Yesterday I was able to paint an olive pitcher for Mr. Ware, and he sent me such a beautiful inscription in Greek to put on it, and that made me think of you. . . . Do you know what it means? That my olive trees are the special care of Zeus, "watched by the eye of olive-guarding Jove and by gray-eyed Athena." Isn't it charming?[18]

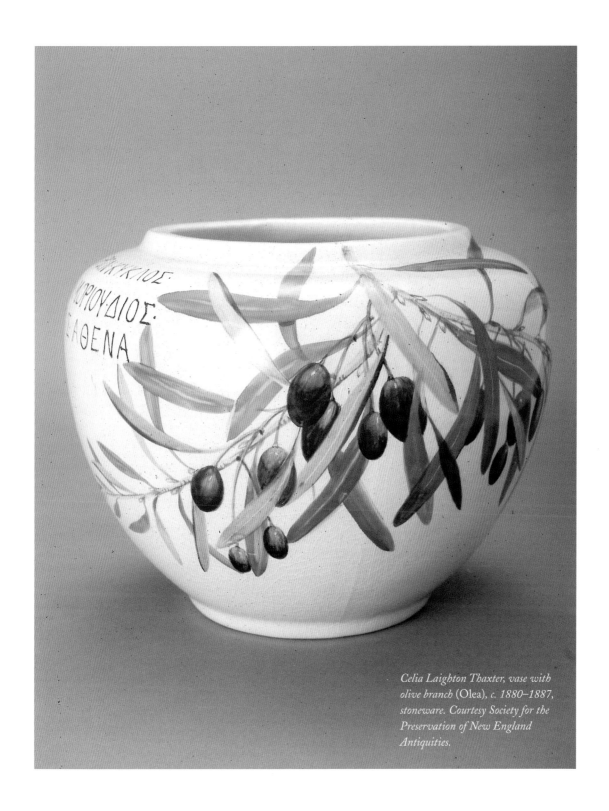

Celia Laighton Thaxter, vase with olive branch (Olea), c. 1880–1887, stoneware. Courtesy Society for the Preservation of New England Antiquities.

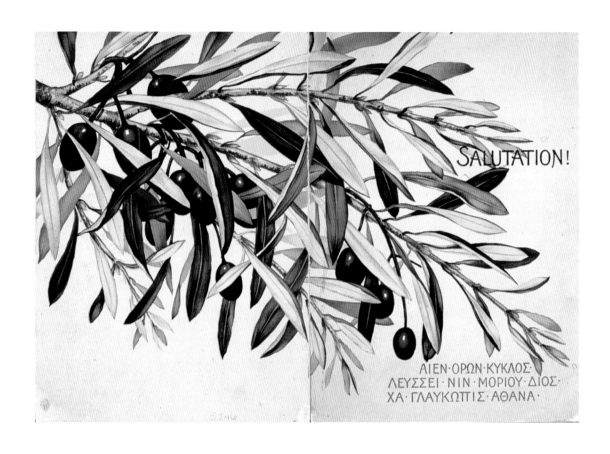

SALUTATION!

ΑΙΕΝ·ΟΡΩΝ·ΚΥΚΛΟΣ·
ΛΕΥΣΣΕΙ·ΝΙΝ·ΜΟΡΙΟΥ·ΔΙΟΣ·
ΧΑ·ΓΛΑΥΚΩΠΙΣ·ΑΘΑΝΑ·

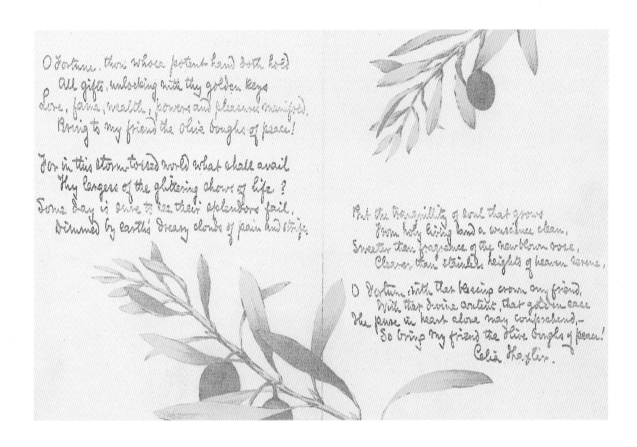

O Fortune, thou whose potent hand doth hold
All gifts, unlocking with thy golden keys
Love, fame, wealth, power and pleasure manifold,
Bring to my friend the olive boughs of peace!

For in this storm-tossed world what shall avail
Thy largess of the glittering showers of life?
Some day is sure to see their splendors fail,
Dimmed by earth's dreary clouds of pain and strife.

But the tranquillity of soul that grows
From holy living and a conscience clean,
Sweeter than fragrance of the new-blown rose,
Clearer than stainless heights of heaven serene,

O Fortune with thy blessing crown my friend,
With that divine content, that golden ease
The pure in heart alone may comprehend,—
So bring my friend the olive boughs of peace!
Celia Thaxter.

*Celia Laighton Thaxter, greeting card
with olive branch* (Olea), *1887, litho-
graph. Courtesy Portsmouth Athenaeum.*

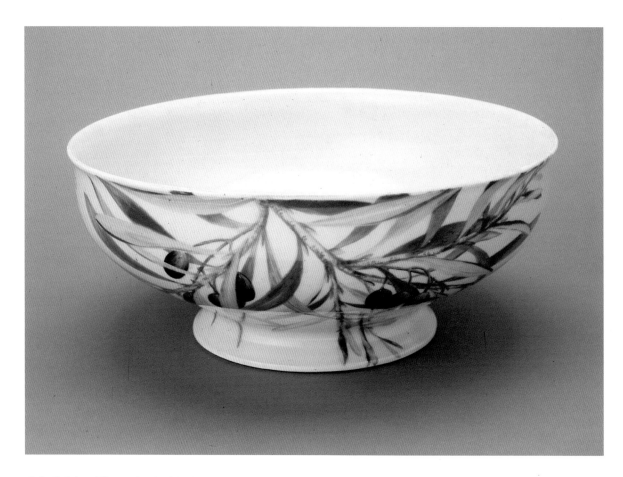

Celia Laighton Thaxter, bowl with olive branch (Olea), *earthenware. Courtesy Celia Thaxter Hubbard.*

OPPOSITE: *Jug with olive branch* (Olea), *1881. stoneware. Courtesy Portsmouth Athenaeum.*

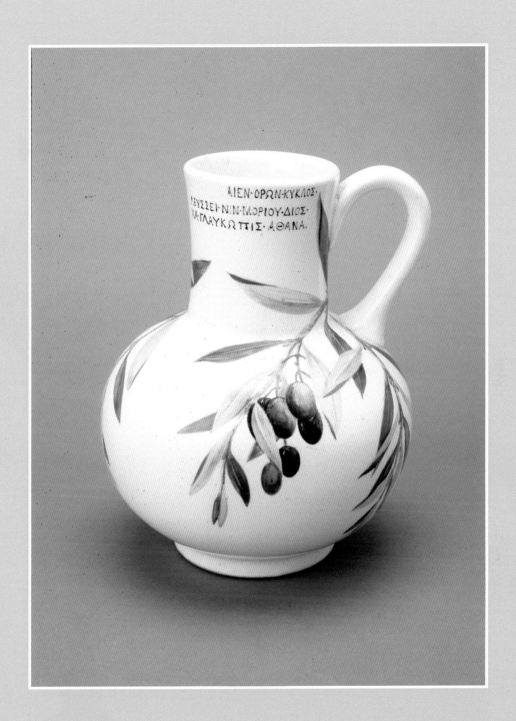

Celia Laighton Thaxter, oil lamp with olive branch (Olea), *n.d., (detail of inscription shown below), porcelain and metal. Courtesy Celia Thaxter Hubbard.*

OPPOSITE TOP: *Celia Laighton Thaxter, bowl with olive branch* (Olea), *1888, porcelain. Courtesy Portsmouth Athenaeum.*

BOTTOM: *Celia Thaxter inscription and signature, 1881, reverse side of china plate with olive branch. Courtesy Society for the Preservation of New England Antiquities.*

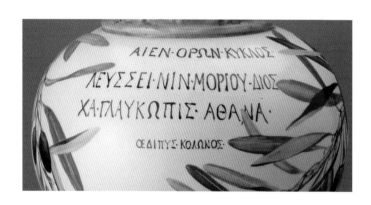

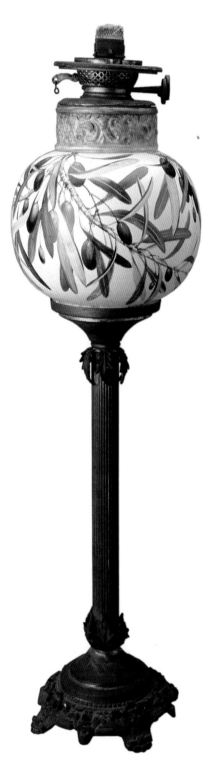

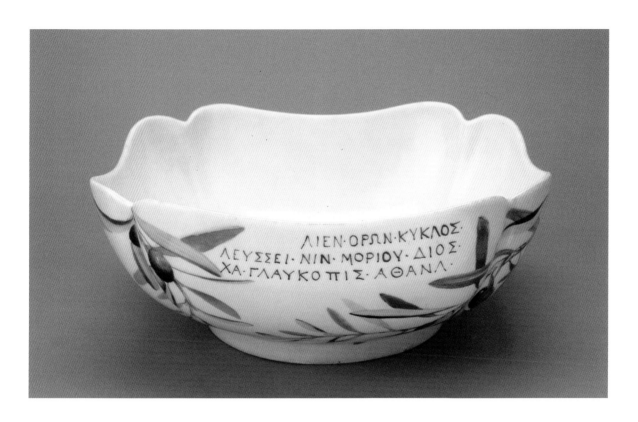

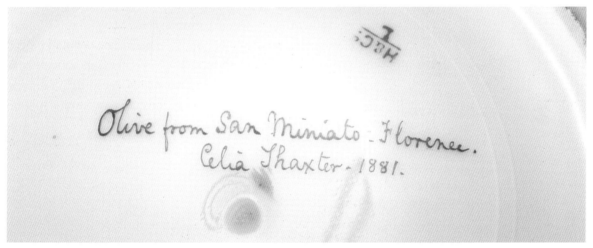

Olive from San Miniato – Florence.
Celia Thaxter – 1881.

Thaxter was one of the early proponents of the naturalistic style in American china painting and chose delicate and simple designs rather than the more common stylized technique. In time she developed a collection of popular motifs. The demand for the olive branch, the poppy, the scarlet pimpernel, and seaweed was high and she reproduced these personally meaningful designs over and over again. Her favorite flowers crept around plates, intertwined on vases, and enveloped cups.

Celia Laighton Thaxter, cake plate with pimpernel (Anagallis arvensis), *1878, porcelain. Courtesy Sandra Smith, on loan to Portsmouth Athenaeum.*

Celia Laighton Thaxter, salad plate with pimpernel (Anagallis arvensis), *1878, porcelain. Courtesy Sandra Smith, on loan to Portsmouth Athenaeum.*

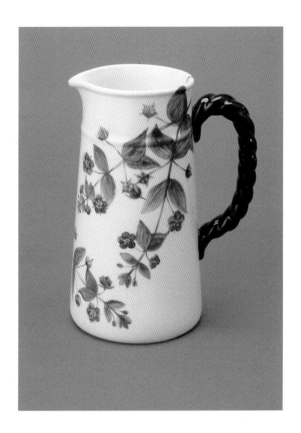

Celia Laighton Thaxter, pitcher with pimpernel (Anagallis arvensis), *1878, porcelain. Courtesy Vaughn Cottage Memorial Library and Museum, Star Island Corporation.*

Celia Laighton Thaxter, cup and saucer with pimpernel (Anagallis arvensis), *1878, porcelain. Courtesy Sandra Smith, on loan to Portsmouth Athenaeum.*

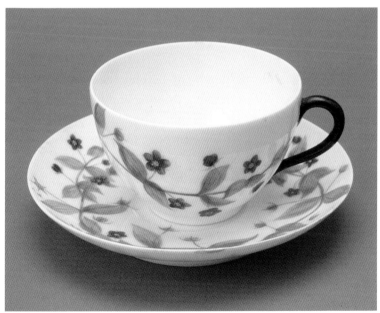

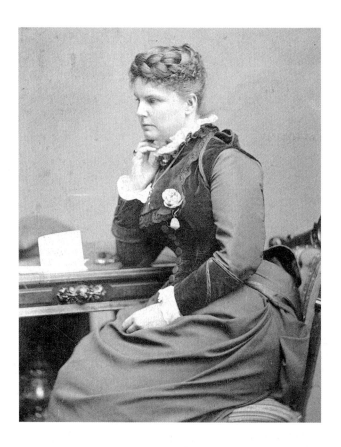

Celia Thaxter, 1875, photograph.
Courtesy Portsmouth Athenaeum.

Thaxter's artistic passion went beyond these practical and financially driven forms of china painting and illustrated works. Her creative spirit was also exemplified in her lifestyle. The elements and principles of design were basic to her perception of the world and permeated her home's decor, her recreational choices, and even her personal style of dress. She was the consummate artist committed to the aesthetic life, creating beauty with disregard for audience or grandeur.

Celia Thaxter (seated behind the easel) in her parlor, c. 1885, photograph. Courtesy Celia Thaxter descendant.

Celia Laighton Thaxter, tiles, 1877–1882, ceramic. Courtesy Celia Thaxter descendant.

OPPOSITE: *Celia Thaxter's mantle with painted tiles and flowers, photograph. Courtesy Celia Thaxter descendant.*

As previously noted, flowers were Thaxter's preferred subject in her paintings and illustrations. For this avid gardener, however, flowers were also a chosen artistic medium. Gathering blossoms for her parlor each morning, she created a living canvas. The cutting garden on Appledore Island was a rambling, unruly explosion of color that reached out to the sea beyond the garden fence. In contrast, the fragrant, massed floral designs in her cottage demonstrated a controlled approach to color theory and monochromatic gradation. Offering a study in line, form, color, and texture, she took a great deal of pleasure in her work.

Thaxter's flowers were not the grand bouquets of the time, but rather massed collections of various-sized vases containing one or two blooms. Photographs of her salon show flowers arranged in scattered clusters covering every available surface. The salon was a stage for a performance where each flower played an essential role in the overall production. Texas floral designer Linda Anderle observes:

> *Celia Thaxter was a flower arranger. She knew her place in their presence and became one with them. She lived within each flower for a moment and then set it aside in its own honored space to be admired. She shared again what her soil had given her. For this was the reward of her gardening, to cut the blossom and place it in a vase and hold it for yet one more hour—an art form that touched every emotion.*[19]

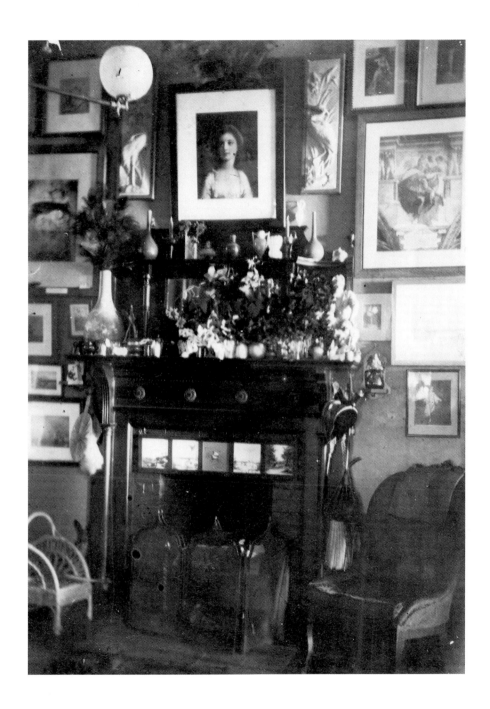

Photographs of Thaxter's parlor and piazza and the lovely watercolors painted by Childe Hassam to illustrate her volume *An Island Garden* validate that her floral design was indeed an art form. In *An Island Garden*, Thaxter herself describes her floral art in every detail:

> *The flowers are of all heights (the stems of different lengths), and, though massed, are in broken and irregular ranks, the tallest standing a little over two feet high. But there is no crushing or crowding. Each individual has room to display its full perfection. The color gathers, softly flushing from the snow white at one end, through all rose, pink, cherry, and crimson shades, to the note of darkest red; the long stems of tender green showing through the clear glass, the radiant tempered gold of each flower illuminating the whole. Here and there a few leaves, stalks, and buds (if I can bring my mind to the cutting of these last) are sparingly interspersed at the back. The effect of this arrangement is perfectly beautiful. It is simply indescribable, and I have seen people stand before it mute with delight. It is like the rose of dawn.*

> *To the left of this altar of flowers is a little table, upon which a picture stands and leans against the wall at the back. In the picture two Tea Roses long since faded live yet in their exquisite hues, never indeed to die. Before this I keep always a few of the fairest flowers, and call this table the shrine. Sometimes it is a spray of Madonna Lilies in a long white vase of ground glass, or beneath the picture in a jar of yellow glass floats a saffron-tinted Water Lily, the Chromatella, or a tall sapphire glass holds deep blue Larkspurs of the same shade, or in a red Bohemian glass vase are a few carmine Sweet Peas, another harmony of color, or a charming dull red Japanese jar holds a few Nasturtiums that exactly repeat its hues. The lovely combinations and contrasts of flowers and vases are simply endless.*[20]

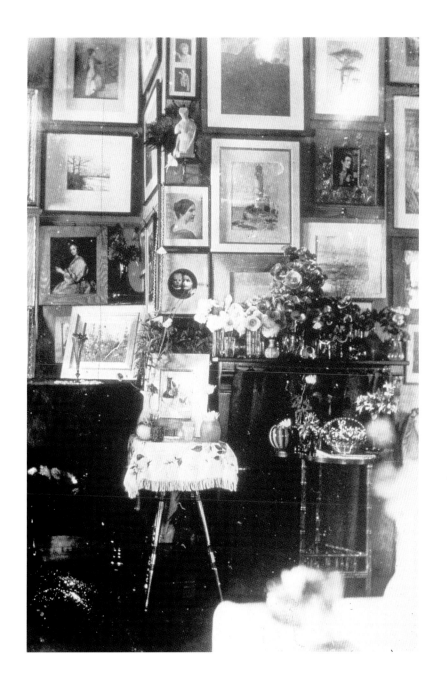

"…and they look loveliest, I think,

when each color is kept by itself."

—CELIA LAIGHTON THAXTER

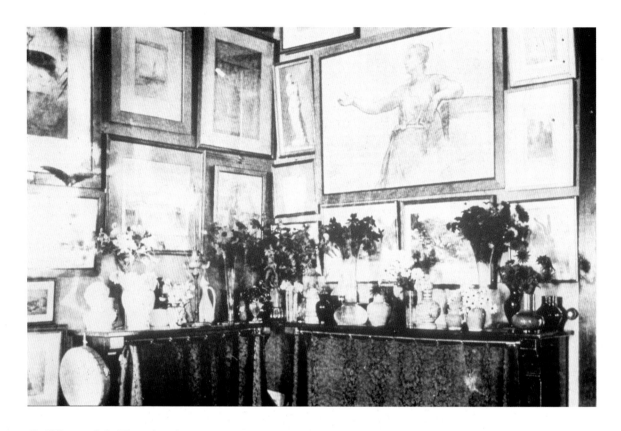

Karl Thaxter. Celia Thaxter's parlor,
bookcases, Appledore Island, c. 1880,
photograph. Courtesy Portsmouth
Athenaeum.

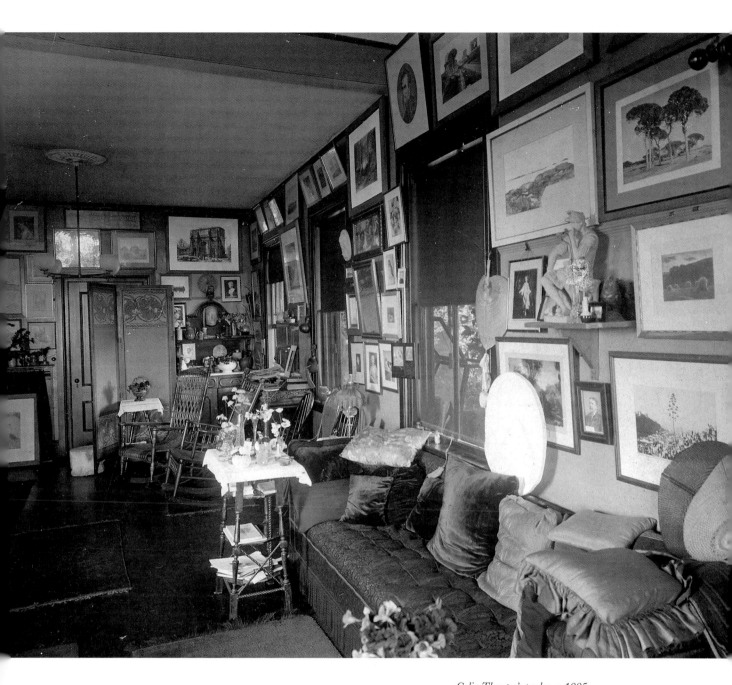

*Celia Thaxter's parlor, c. 1885,
photograph. Courtesy Celia Thaxter
descendant.*

Candace Wheeler, a contemporary of Thaxter and guest in her parlor, recalled Thaxter's flowers in *Content in a Garden:* "I have never anywhere seen such realized possibilities of color! The fine harmonic sense of the woman and artist and poet thrilled through these long cords of color, and filled the room with an atmosphere which made it seem like living in a rainbow."[21]

The creation of beauty was a role Thaxter viewed seriously. In the lobby of the Appledore House, vases marched singly down the long stretch of the front desk. They were as much a part of the gracious aesthetic as the paintings on the walls and the sea just beyond the door. They drew the attention of guests into the creative atmosphere of their surroundings. Beyond providing a visual feast or a stimulating creative medium, the flowers in her world were a valuable resource for communicating expressions of hospitality, joy, sorrow, and contentment. Garden flowers and seeds were regularly exchanged with friends and pressed flowers were frequently included in letters. In a diary belonging to Annie Fields an entry records, "July 31, 1866—pressed flowers from Celia Thaxter's garden."[22] Also, tucked in a few of Thaxter's poetry books now owned and treasured by her descendants are pressed flowers, leaves, and feathers.

In addition to the extraordinary interest shown in flowers and gardening, the plants and mosses of the sea held mystical appeal for women in the Victorian era. These seaside naturalists combed the coastline gathering "blossoms of the deep" to press and preserve. Pictures composed of seaweed and marine algae were elaborately framed, and many anonymous nineteenth-century albums are the basis for today's valuable collections of herbaria.

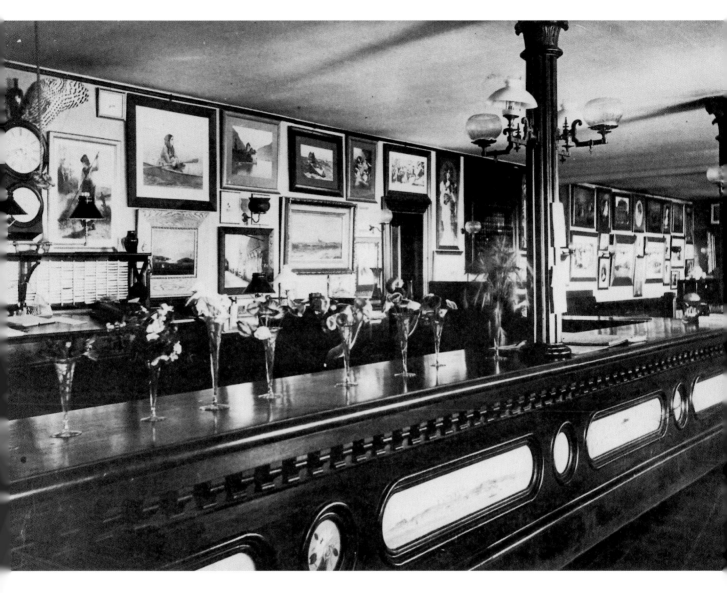

Appledore House front desk, c. 1885,
photograph. Courtesy Portsmouth
Athenaeum, Lyman Rutledge Collection.

Maggie L. Woodruff.

Celia Thaxter.

Appledore, Isles of Shoals.

Aug. 1er 1875.

"*Great is the pleasure
in the giving and the taking*"

—Celia Laighton Thaxter

Shoals. 28th Oct
1874.

The pimpernel dozed on the lea, grandfather.
But this letter paper doesn't take the colors very well,
& I am as yet unskilled— but I tried my best to copy it
faithfully. I love it to distraction, with all its tricks
& its manners,— the real thing I mean, not my feeble
attempt at its copy.

You kind grandfather, how good you were to write
me such a charming letter! Truly my exile begins
to lose some of its terrors, so enlivened. I had a beautiful
letter from Mr. Whittier, too, at the same time, & lots
of kind people write to me & cheer my loneliness. But

with love from
Celia Thaxter.

Appledore. June 6th 1875.

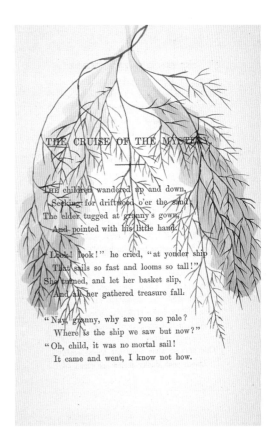

EXPECTATION. 15

But this one golden moment,— hold it fast !
 The light grows long : low in the west the sun,
Clear red and glorious, slowly sinks at last,
 And while I muse, the tranquil day is done.

The land breeze freshens in thy gleaming sail !
 Across the singing waves the shadows creep :
Under the new moon's thread of silver pale,
 With the first star, thou comest o'er the deep

THE CRUISE OF THE MYSTERY.

The children wandered up and down,
 Seeking for driftwood o'er the sand ;
The elder tugged at granny's gown,
 And pointed with his little hand.

"Look ! look !" he cried, "at yonder ship
 That sails so fast and looms so tall !"
She turned, and let her basket slip,
 And all her gathered treasure fall.

"Nay, granny, why are you so pale ?
 Where is the ship we saw but now ?"
"Oh, child, it was no mortal sail !
 It came and went, I know not how.

Celia Laighton Thaxter, illustrated page—seaweed, watercolor over set type, from Celia Thaxter, Poems, 1882. Courtesy Bill and Sharon Stephan.

Celia Laighton Thaxter, illustrated page—seaweed, watercolor over set type, from Celia Thaxter, The Cruise of the Mystery, and Other Poems, 1886. Courtesy Donna Marion Titus.

OPPOSITE: *Celia Laighton Thaxter, basket with seaweed, 1882, porcelain. Courtesy Portsmouth Athenaeum.*

Fascinated by the elusive beauty of marine life, Thaxter scoured the rocks and shore for delicate specimens of seaweed and sea moss to dry, press, and study for her watercolors and china painting. In hues ranging from pink to mauve to burgundy, gold, rust, and multiple shades of green, she captured their colorful glory and revealed the details of their form on paper and on porcelain. She arranged the "tendrils of sea moss and wisps of seaweed" in graceful forms for preservation in albums.[23] In *Noted Women of Europe and America*, James Parton recalled, "I have had the pleasure of visiting the little parlor of her cottage, and I . . . enjoyed in their company a collection of sea-weeds, of which she carefully pointed out and described the most curious."[24]

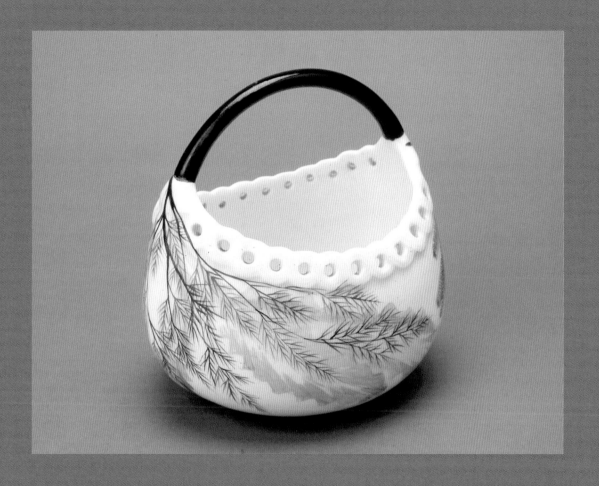

"His sister, Mrs. Celia Thaxter, gave him a large vase or jar, exquisitely decorated by herself with paintings of seaweed and mosses so as to fairly rival nature . . ."

—Celia Laighton Thaxter

Celia Laighton Thaxter, serving dish with seashell and seaweed, 1878, porcelain. Courtesy Celia Thaxter Hubbard.

Celia Laighton Thaxter, sketchbook—seashell (Mussel), watercolor. Courtesy Celia Thaxter Hubbard.

Celia Laighton Thaxter, illustrated letter—seashell (Mussel), correspondence to Rev. John Weiss, 1874, watercolor. Courtesy Colby College, Miller Library, Special Collections.

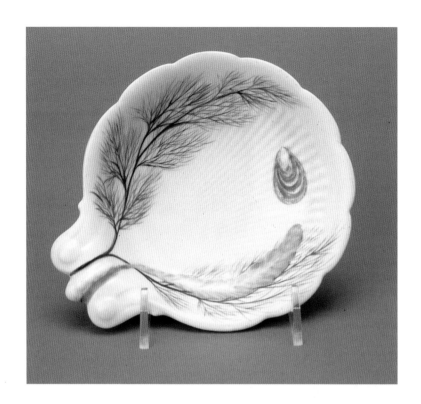

Shoals. Nov. 22nd
1874.

"You have no news, nothing to communicate"? O Grandfather! and you tell me this delightful story of Tyndalls gardners which makes me glow with joy! Well may he be glad a friend! Well may you both be. Hardly can I conceive of any greater human satisfaction. Dear grandfather, I am so rejoiced to hear about it. I thank you so much for telling me! It was good of you. but you knew how happy it would make me. "You were afraid what you wrote would be stuff to me"? Very precious stuff, I can assure you! I need not say

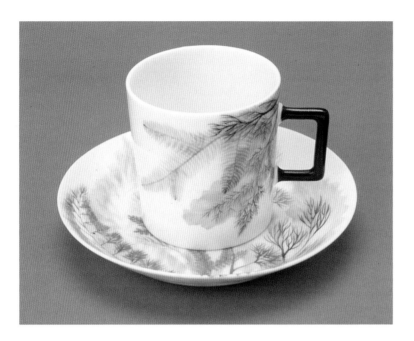

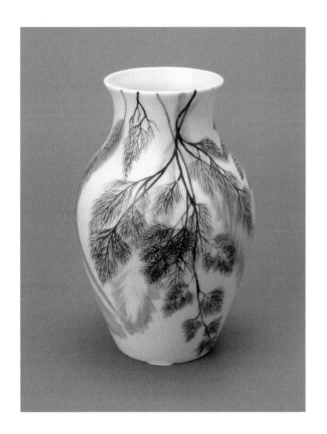

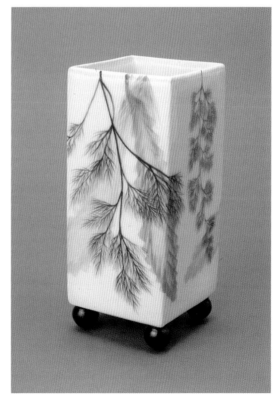

Celia Laighton Thaxter, cup and saucer with seaweed, demitasse, 1880, porcelain. Courtesy Vaughn Cottage Memorial Library and Museum, Star Island Corporation.

Celia Laighton Thaxter, vase with seaweed, 1879, porcelain. Courtesy Celia Thaxter descendant

Celia Laighton Thaxter, vase with seaweed, footed, 1878, porcelain. Courtesy Vaughn Cottage Memorial Library and Museum, Star Island Corporation.

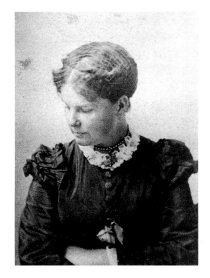

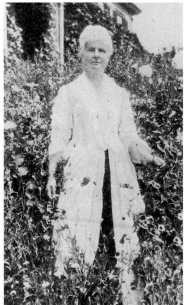

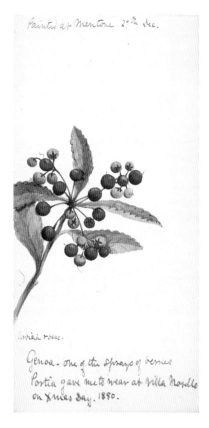

Celia Thaxter, age 21, 1856, lantern slide. Courtesy Portsmouth Athenaeum.

Celia Thaxter in her garden, c. 1890, photograph. Courtesy Portsmouth Athenaeum.

Celia Laighton Thaxter, sketchbook— berries (Ardisia crenata) worn Christmas 1880, watercolor. Courtesy Celia Thaxter Hubbard.

OPPOSITE: *Karl Thaxter. Celia Thaxter entering piazza with flowers in hand, c. 1890, photograph. Courtesy Portsmouth Athenaeum.*

Even Celia Thaxter's appearance evidenced her commitment to her own individualistic artistic vision. She dressed with simplicity and grace, choosing modest designs in white, gray, or black over the more colorful styles of the period. Her clothing, like the gray rocks of the Shoals, presented a neutral background for artistic embellishment with simple flowers or seashells. She strung periwinkle shells or rosehips to wear around her neck or wrist and sometimes added a crescent ornament to her hair or a fichu, a shawl-type wrap, around her shoulders. Photographs taken of her in her garden frequently show her wearing a long white duster to protect her clothing. Unaffected by popular trends of the day, Thaxter's approach to painting, writing, gardening, floral design, and personal appearance was modest, natural, and unique.

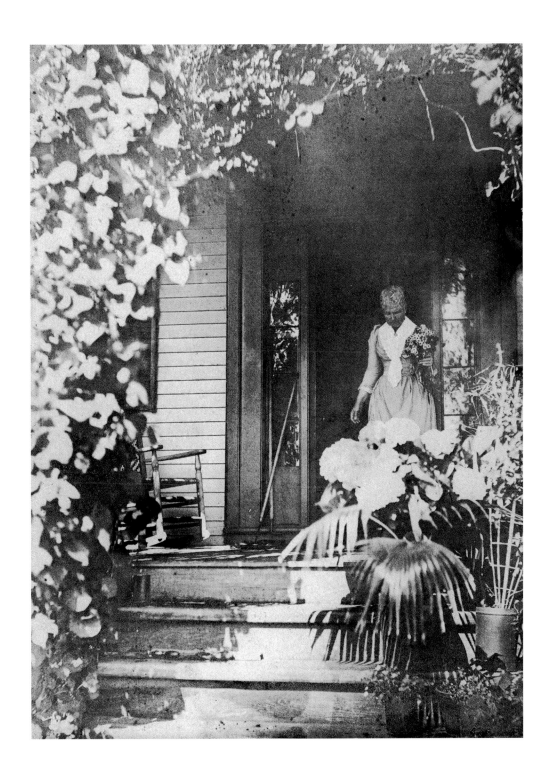

Although Thaxter's parlor walls were weighted with the heavy excess of the late nineteenth century, her art was not. She was an accurate and faithful illustrator of her island environment and her interpretation of beauty was clean and honest. The Isles of Shoals served as home, sanctuary, and an inspiration that profoundly shaped her inner voice. Thaxter teaches us to notice nature, to embrace its beauty, and to find contentment within its magic.

VESPER SONG

Lies the sunset splendor far and wide,
On the golden tide!
Drifting slow toward yonder evening red,
With the faint stars sparkling overhead,
Peacefully we glide.

Sweet is rest: the summer day is done,
Gone the ardent sun.
All is still: no wind of twilight blows;
Shuts the evening like a crimson rose;
Night comes like a nun.

Lift we loving voices, pure and clear,
To the Father's ear;
Fragrant as the flowers the thoughts we raise
Up to heaven, while o'er the ocean ways
Draws the darkness near.

Celia Laighton Thaxter, Vesper Song, *photograph and poem (framed). Courtesy Society for the Preservation of New England Antiquities.*

Vesper Song.

Lies the sunset splendor far and wide
 On the golden tide;
Drifting slow toward yonder evening red
With the faint stars sparkling over-head,
 Peacefully we glide.

Sweet is rest: the summer day is done,
 Gone the ardent sun.
All is still: no wind of twilight blows;
Shuts the evening like a crimson rose;
 Night comes like a nun.

Lift we loving voices pure and clear
 To the Father's ear:
Fragrant as the flowers the thoughts we raise
Up to heaven while o'er the ocean ways
 Draws the darkness near.

 Celia Thaxter.

Celia Laighton Thaxter, vase with pimpernel (Anagallis arvensis), *1880, earthenware. Courtesy Vaughn Cottage Memorial Library and Museum, Star Island Corporation.*

OPPOSITE: *Celia Laighton Thaxter, illustrated page—pimpernel* (Anagallis arvensis), *watercolor over set type, from Celia Thaxter,* Poems, *1882. Courtesy Sandra Smith, on loan to Portsmouth Athenaeum.*

Celia Laighton Thaxter's life, literature, and art are unique and inseparable. She embellishes volumes of her poetry with tiny seascapes and details of island plants, flowers, and seaweed. Selected pieces of her hand-painted china feature lines of verse tucked among the plants and blossoms. Capturing nature's artistry in paint, poetry, and prose, her work constitutes a powerful form of personal expression. While she exploits the popular trends of the nineteenth century, her artistic creations remain original and distinctive. Today they represent a woman's search for self-reliance, confidence, and serenity in the pursuit of her creative passion.

Sharon Paiva Stephan

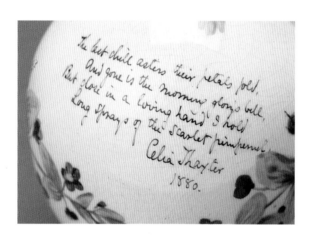

The last chill asters their petals fold,
And gone is the morning glory's bell,
But close in a loving hand I hold
Long sprays of the scarlet pimpernel.

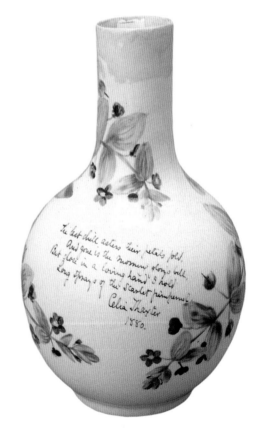

THE PIMPERNEL.

SHE walks beside the silent shore,
 The tide is high, the breeze is still ;
No ripple breaks the ocean floor,
 The sunshine sleeps upon the hill.

The turf is warm beneath her feet,
 Bordering the beach of stone and shell,
And thick about her path the sweet
 Red blossoms of the pimpernel.

"O, sleep not yet, my flower !" she cries,
 " Nor prophesy of storm to come ;
Tell me that under steadfast skies
 Fair winds shall bring my lover home."

She stoops to gather flower and shell,
 She sits, and smiling, studies each ;
She hears the full tide rise and swell,
 And whisper softly on the beach.

8

1. See essay by Mandel in this volume.

2. Lovell Thompson, et al., eds. *Youth's Companion* (Boston: Houghton Mifflin Company, 1954), 503.

3. See essays by Vallier and Robinson in this volume.

4. "This woman is a find—an American garden writer in the tradition of V. Sackville West, Eleanor Pereny, etc. a treasure." Jacqueline Kennedy Onassis, notations.

5. See essay by Wetzel in this volume.

6. Celia Thaxter, letter to Rev. George Bainton, Appledore, 10 April 1889, Portsmouth Athenaeum, Portsmouth, New Hampshire.

7. William D. Howells, *Literary Friends and Acquaintance* (New York: Harper & Brothers Publishers, 1902), 124.

8. Thaxter's husband, Levi, shared her interest in nature, though in plant identification rather than visual representation. The couple's youngest son, Roland, became an eminent professor of cryptogamic botany at Harvard, inheriting both his father's scientific bent and his mother's talent as a miniaturist. Roland's skill at accurately reproducing the details of microscopic organisms was well recognized by his peers, and originals of his meticulous scientific drawings are still kept at Harvard's Farlow Library. "Roland Thaxter (1858–1932)" by Carroll W. Dodge, *Annales de Cryptogamie Exotique*, juillet 1933, Tome VI, Fasc. 1, Museum National d'Histoire Naturelle, Paris.

9. Celia Thaxter, letter to Feroline W. Fox, Shoals, 22 September 1874, Annie Fields and Rose Lamb, eds. *Letters of Celia Thaxter* (Boston: Houghton Mifflin, 1895), 58.

10. Celia Thaxter, letter to Dr. Richard Derby, Appledore, 11 December 1876, Annie Fields and Rose Lamb, eds. *Letters of Celia Thaxter* (Boston: Houghton Mifflin, 1895), 81–82.

11. Celia Thaxter, letter to Annie Fields, Newtonville, 22 April 1872, Papers of Annie Fields, Boston Public Library, Boston, Massachusetts.

12. Celia Thaxter, letter to Annie Fields, Shoals, 2 May 1880, James and Annie Fields Collection, Huntington Library, San Marino, California.

13. Celia Thaxter, letter to Mr. Stoddard, Shoals, 26 August 1891, Milne Special Collections and Archives, University of New Hampshire, Durham.

14. Brandimarte, C.A., *Somebody's Aunt and Nobody's Mother: The American China Painter and Her Work, 1870–1920.* Winterthur Portfolio, 1988, 23(4), 203–24.

15. Personal collection.

16. Roger B. Stein writes of Thaxter in "Artifact as Ideology: The Aesthetic Movement in Its American Cultural Context," *In Pursuit of Beauty: Americans and the Aesthetic Movement* (New York: Metropolitan Museum of Art, 1986): "Her artistic task was to discover forms to give shape to her vision, but since her writing paid little, she needed to find other means of support . . . Thaxter turned to painting, copying from nature . . . The sustenance offered her by mimetic transformation of natural fact into pictorial image she channeled practically into the making of aesthetic commodities."

17. Celia Thaxter, letter to Annie Fields, Menton, France, 31 December 1880, James and Annie Fields Collection, Huntington Library, San Marino, California.

18. Annie Fields and Rose Lamb, eds. *Letters of Celia Thaxter* (Boston: Houghton Mifflin, 1895), 125.

19. Personal communication.

20. Celia Thaxter, *An Island Garden* (Boston: Houghton Mifflin, 1894), 96.

21. Candace Wheeler, *Content in a Garden* (Boston: Houghton Mifflin, 1901).

22. Annie Fields, diary, 31 July 1866, James and Annie Fields Collection, Huntington Library, San Marino, California.

23. A fine example of Thaxter's work with marine algae is housed at the Houghton Library, Harvard University, Cambridge, Massachusetts.

24. James Parton, *Noted Women of Europe and America* (Hartford: Phoenix Publishing Company, 1883), 12.

Checklist of the Exhibition

Measurement is given in inches, height preceding width.

PAINTINGS

Champernowne Farm and Elm
1884; initialed and dated
Watercolor; 9 x 12
Courtesy Celia Thaxter descendant

Field of Gold Flowers, City Towers
Signed verse
Watercolor; 15 $1/2$ x 18 $1/2$
Courtesy Martha DeNormandie

Lunging Island Panorama
Inscribed
Watercolor; 9 $1/4$ x 45 $3/8$
Courtesy Celia Thaxter descendant

Madame Champernowne in Parlor
1883
Watercolor; 10 x 14
Courtesy Celia Thaxter descendant

Seapoint Beach
Watercolor; 12 $3/4$ x 16 $3/4$ (framed)
Courtesy Celia Thaxter descendant

White Island Lighthouse
Signed
Watercolor; 9 x 12
Courtesy Margaret V. H. Hubbard

White Island Lighthouse
1883; signed and dated
Watercolor; 25 $1/2$ x 19 $1/2$ (framed)
Courtesy Celia Thaxter Hubbard

ILLUSTRATED BOOKS

The Cruise of the Mystery, and Other Poems
20 watercolors over set type
Houghton, Mifflin and Company, Boston, 1886
6 $3/4$ x 4 $3/8$
Courtesy Donna Marion Titus

Poems
21 watercolors over set type
Hurd & Houghton, NY, 1873
6 x 4 $3/8$
Courtesy Mr. & Mrs. Fred McGill

Poems
8 watercolors over set type; inscribed
Hurd & Houghton, NY, 1874
6 x 4 $3/8$
Courtesy Celia Thaxter Hubbard

Poems
21 watercolors over set type; inscribed
Hurd & Houghton, NY, 1874
6 x 4 $3/8$
Courtesy Portsmouth Athenaeum

Poems
20 watercolors over set type
Houghton, Mifflin and Company, Boston, 1882
6 x 4 $3/8$
Courtesy Bill and Sharon Stephan

Poems
23 watercolors over set type; signed
Houghton, Mifflin and Company, Boston, 1882
6 x 4 $3/8$
Courtesy Celia Thaxter Hubbard

Poems
19 watercolors over set type; signed
Houghton, Mifflin and Company, Boston, 1882
6 x 4 ³⁄₈
Courtesy Sandra Smith, on loan to Portsmouth
 Athenaeum

Poems
19 watercolors over set type
Houghton, Mifflin and Company, Boston, 1886
6 x 4 ³⁄₈
Courtesy Celia Thaxter descendant

Poems
16 watercolors over set type
Houghton, Mifflin and Company, Boston, 1891
6 x 4 ³⁄₈
Courtesy Bill and Sharon Stephan

SKETCHBOOKS

Sketchbook
1880-1881
Bound book; 3 ³⁄₄ x 7 ¹⁄₂
Courtesy Celia Thaxter Hubbard

Sketchbook
1874
Bound book; 5 ¹³⁄₁₆ x 9
Courtesy Celia Thaxter Hubbard

Sketchbook
n.d.
Bound book; 7 x 10 ³⁄₄
Courtesy Portsmouth Athenaeum

LETTERS

Framed Correspondence
October 4, 1881
6 x 5
Relating to gift of hand-painted marigold pitcher
Courtesy Strawbery Banke Museum, 1987.1108

Letter Illustrated with Yellow Elm Leaf
October 17, 1874
Watercolor; 6 x 5
Courtesy Special Collections, Miller Library,
 Colby College, Waterville, Maine

Letter Illustrated with Scarlet Pimpernel
October 28, 1874
Watercolor; 6 x 5
Courtesy Special Collections, Miller Library,
 Colby College, Waterville, Maine

Letter Illustrated with Purple Mussel Shell
November 22, 1874
Watercolor; 6 x 5
Courtesy of Special Collections, Miller Library,
 Colby College, Waterville, Maine

CERAMIC OBJECTS

Aster and Butterfly Vase
1880; signed and dated
Decorated with purple asters and butterflies
Earthenware; 3 ¹⁄₂ x 3 ¹⁄₂ x 8
Courtesy Vaughn Cottage Memorial Library
 and Museum, Star Island Corporation, O-17

Aster Plate
1881; signed and dated
Decorated with purple asters
Porcelain; 7 ¹⁄₄ diameter
Courtesy Vaughn Cottage Memorial Library
 and Museum, Star Island Corporation, O-18

Autumn Pitcher
1878; signed and dated
Decorated with maple leaf and fruit, and
 purple asters
Porcelain; 3 high
Courtesy Bruce and Carole Parsons

Butter Chip
1886; signed and dated
Shaped and decorated as daisy
Porcelain; 2 $^3/_4$ diameter
Courtesy Vaughn Cottage Memorial Library
 and Museum, Star Island Corporation, O-43

Daffodil Vase
1882; signed and dated
Decorated with yellow daffodils
Earthenware; 7 $^1/_4$ high
Courtesy Strawbery Banke Museum, 1987.738

Iris Pitcher
1878; signed, dated, and inscribed
Decorated with purple iris
Porcelain; 6 $^3/_8$ high
Courtesy Prudence C. Randall

Lilac Cup and Saucer
1884; signed and dated
Decorated with violet lilacs, butterfly handle
Porcelain; 3 $^1/_2$ high
Courtesy Society for the Preservation
 of New England Antiquities, Gift of
 Mr. Goddard White, 1925.526

Marigold Pitcher
1881; signed and dated
Decorated with marigolds
Earthenware; 5 $^1/_4$ x 5 $^1/_8$
Courtesy Strawbery Banke Museum, 1987.737

Olive Branch Bowl
1887; signed and dated
Decorated with olive branches and Greek
 inscription
Porcelain; 10 $^1/_4$ diameter
Courtesy Celia Thaxter Hubbard

Olive Branch Bowl
1888; signed and dated
Square bowl decorated with olive branches and
 Greek inscription
Porcelain; 4 $^1/_4$ x 10 $^1/_8$
Courtesy Portsmouth Athenaeum, S243

Olive Branch Lamp
Decorated with olive branches and Greek
 inscription
Porcelain and metal; 26 high
Courtesy Celia Thaxter Hubbard

Olive Branch Jug
1881; signed and dated
Decorated with olive branches and Greek
 inscription
Stoneware; 6 $^1/_2$ high
Courtesy Portsmouth Athenaeum, S245

Olive Branch Vase
1882; signed and dated
Decorated with olive branches
Porcelain; 6 $^1/_4$ high
Courtesy Celia Thaxter Hubbard

Pimpernel Cake Plate
1878; signed and dated
Decorated with scarlet pimpernel
Porcelain; 9 $^1/_2$ diameter
Courtesy Sandra Smith, on loan to Portsmouth
 Athenaeum

Pimpernel Cup and Saucer
1878; signed and dated
Decorated with scarlet pimpernel
Porcelain; 2 $\frac{1}{4}$ x 3 $\frac{1}{2}$ (cup); 5 $\frac{1}{2}$ diameter (saucer)
Courtesy Sandra Smith, on loan to Portsmouth
 Athenaeum

Pimpernel Pitcher
1878; signed, dated and inscribed
Decorated with scarlet pimpernel
Earthenware; 5 high
Courtesy Vaughn Cottage Memorial Library
 and Museum, Star Island Corporation, O-37

Pimpernel Salad Plate
1878; signed and dated
Decorated with scarlet pimpernel
Porcelain; 7 $\frac{1}{4}$ diameter
Courtesy Sandra Smith, on loan to Portsmouth
 Athenaeum

Pimpernel Vase
1880; signed and dated
Decorated with scarlet pimpernel and original verse
Earthenware; 5 $\frac{3}{4}$ high
Courtesy Vaughn Cottage Memorial Library
 and Museum, Star Island Corporation, O-145

Seaweed Basket
1882; signed and dated
Decorated with various seaweed
Porcelain; 5 high
Courtesy Portsmouth Athenaeum, S242

Seaweed Demitasse Cup and Saucer
1880; signed and dated .
Decorated with various seaweed
Porcelain; 2 x 2 $\frac{1}{8}$ (cup); 4 $\frac{1}{4}$ diameter (saucer)
Courtesy Vaughn Cottage Memorial Library
 and Museum, Star Island Corporation, O-29(a,b)

Seaweed Serving Dish
1878; signed and dated
Decorated with seaweed and mussel shell
Porcelain; 5 $\frac{5}{8}$ diameter
Courtesy Celia Thaxter Hubbard

Seaweed Vase
1878; signed and dated
Square vase decorated with various seaweed
Porcelain; 6 $\frac{3}{8}$ high
Courtesy Vaughn Cottage Memorial Library
 and Museum, Star Island Corporation, O-27

Seaweed Vase
1879; signed and dated
Decorated with various seaweed
Porcelain; 5 $\frac{5}{16}$ high
Courtesy Celia Thaxter descendant

Sunset Plate with Sailboat
1878; signed and dated
Decorated with sunset scene
Porcelain; 6 $\frac{3}{4}$ diameter
Courtesy Society for the Preservation of
 New England Antiquities, General Collection,
 1931.5

Violet Pitcher
1882; signed and dated
Decorated with violet
Porcelain; 3 $\frac{1}{2}$ x 1 $\frac{1}{2}$
Courtesy Portsmouth Athenaeum, S241

Violet Teacup
1888; signed and dated
Decorated with violets, butterfly handle
Porcelain; 2 $\frac{1}{4}$ x 3 $\frac{1}{2}$
Courtesy Vaughn Cottage Memorial Library
 and Museum, Star Island Corporation, O-23a

Violet Saucer
1881; signed and dated
Decorated with violets
Porcelain; 5 $^1/_2$ diameter
Courtesy Vaughn Cottage Memorial Library
 and Museum, Star Island Corporation, O-26

Wild Rose Vase
1883; signed and dated
Decorated with pink roses
Porcelain; 10 high
Courtesy Celia Thaxter descendant

Wild Rose Cup and Saucer
1879; signed and dated
Decorated with pink roses, butterfly handle
Porcelain; 2 $^3/_8$ x 3 $^1/_4$ x 4 $^3/_4$ (cup)
Courtesy Society for the Preservation
 of New England Antiquities, Gift of
 Boylston Adams Beal, 1934.2063

Wild Rose Cup and Saucer
1881; signed and dated
Decorated with pink roses
Porcelain; 2 $^1/_4$ x 3 $^1/_2$ x 4 $^1/_4$ (cup);
 5 $^1/_2$ diameter (saucer)
Courtesy Vaughn Cottage Memorial Library
 and Museum, Star Island Corporation, O-32(a,b)

Wild Rose Plate
1881; signed and dated
Decorated with pink roses
Porcelain; 7 $^1/_4$ diameter
Courtesy Vaughn Cottage Memorial Library
 and Museum, Star Island Corporation, O-31

MISCELLANEOUS

Framed Illustrated Page
Watercolor over set type (Pine needles)
c. 1880s
6 x 4 $^3/_8$
From Celia Thaxter, *Poems*
Courtesy Bill and Sharon Stephan

Framed Illustrated Page
Watercolor over set type (Poppy)
c. 1880s
6 x 4 $^3/_8$
From Celia Thaxter, *Poems*
Courtesy Bill and Sharon Stephan

Framed Photo with Original Verse
c.1885–1900
Paper and wood; 14 $^1/_4$ x 6 $^7/_8$ (framed)
Courtesy Society for the Preservation of
 New England Antiquities, Gift of Mrs. George
 S. Selfridge, 1926.329

Framed Tiles
c.1877–1882; signed and dated
Decorated with hand-painted scenes
Ceramic and wood; 6 x 6 (tiles)
7 $^3/_4$ x 34 $^5/_8$ (framed)
Courtesy Celia Thaxter descendant

Greeting Card
1887; printed by L. Prang & Co., Boston
Decorated with olive branch, Greek inscription
 with poem on inside
7 x 10 (open)
Courtesy Portsmouth Athenaeum, S246

Paint Box and Palette
Metal box with paint tubes, palette,
 and brush; 13 $^5/_{16}$ x 9 $^1/_1$ x 2 $^3/_4$
Courtesy Bill and Sharon Stephan

PHOTOGRAPHS

Appledore from the Sea
c. 1881
Copy print; 12 $\frac{1}{2}$ x 19 $\frac{1}{4}$
Courtesy Portsmouth Athenaeum, Isles of Shoals
 Collection

Appledore House Bathing Pool
c. 1870–80s
Copy print; 14 $\frac{3}{4}$ x 18 $\frac{3}{4}$
Courtesy Portsmouth Athenaeum, Isles of Shoals
 Collection

Appledore House Front Desk
c. 1880s
Copy print; 9 $\frac{1}{2}$ x 13 $\frac{1}{2}$
Courtesy Bill and Sharon Stephan

Celia Thaxter
1886
Copy print; 8 x 10
Courtesy Portsmouth Athenaeum, Isles of Shoals
 Collection

Celia Thaxter on Cottage Porch
c. 1887
Copy print; 14 x 19
Courtesy Portsmouth Athenaeum

Celia Thaxter with sons John and Karl
1856
Copy print; 14 x 18
Courtesy Portsmouth Athenaeum, Isles of Shoals
 Collection

Celia Thaxter's Parlor Flowers
c. 1880s
Copy print; 14 $\frac{1}{2}$ x 17 $\frac{1}{2}$
Courtesy Bill and Sharon Stephan

Guests
c. 1890s
Copy print; 6 x 19 $\frac{1}{4}$
Courtesy Bill and Sharon Stephan

Interior View of Celia Thaxter's Parlor
c. 1890
Copy print; 14 $\frac{3}{4}$ x 19 $\frac{1}{4}$
Courtesy Portsmouth Athenaeum, Lyman Rutledge
 Collection

White Island Lighthouse
c. 1860
Copy print; 14 $\frac{1}{2}$ x 18
Courtesy Portsmouth Athenaeum

Selected Bibliography

Works by Celia Laighton Thaxter

Poems. New York: Hurd and Houghton, 1872.

Among the Isles of Shoals. Boston: James R. Osgood & Co., 1873.

Among the Isles of Shoals. Portsmouth, NH: Peter E. Randall Publisher, 1994.

Drift-Weed. Boston: Houghton, James R. Osgood & Co., 1879.

Poems for Children. Boston: Houghton Mifflin and Company, 1884.

The Cruise of the Mystery, and Other Poems. Boston: Houghton Mifflin and Company, 1886.

Idyls and Pastorals: A Home Gallery of Poetry and Art. Boston: D. Lothrop and Company, 1886.

Yule Log. New York: L. Prang & Company, 1889.

My Lighthouse, and Other Poems. Boston: L. Prang & Company, 1890.

Verses. Boston: D. Lothrop and Company, 1891.

An Island Garden. Boston: Houghton Mifflin and Company, 1894, 1988.

Letters of Celia Thaxter, ed. Annie Fields and Rose Lamb. Boston: Houghton Mifflin and Company, 1895.

Stories and Poems for Children, ed. Sarah Orne Jewett. Boston: Houghton Mifflin and Company, 1895.

The Poems of Celia Thaxter. Appledore Edition. Boston: Houghton Mifflin and Company, 1896.

The Poems of Celia Thaxter. Portsmouth, NH: Peter E. Randall Publisher, 1996.

Parker's Penny Classics: Maize, the Nation's Emblem. No. 189. Taylorville, IL: Parker Publishing Co., 1906.

The Heavenly Guest, ed. Oscar Laighton. Andover, MA: Smith & Coutts Co., 1935.

The Coming of the Swallow. Worcester, MA: Bullard Art Publishing Company, n.d.

The Lost Bell, n.d.

Parker's Lessons in Literature. "The Sandpiper." by Celia Thaxter, also "Sandalphon." by Henry Wadsworth Longfellow. No. 217. Taylorville, IL: Parker Publishing Co., n.d.

Works by Celia Laighton Thaxter in School Readers

The New McGuffey Fourth Reader. New York, Cincinnati, Chicago: American Book Company, 1901.

Bolenius, Emma Miller. *Fourth Reader: The Boys' and Girls' Readers*. Boston: Houghton Mifflin and Company, 1926.

Dunton, Larkin, ed. *The Land of Song: Book One for Primary Grades*. New York: Silver, Burdett & Company, 1898.

Hale, Edward Everett, ed. *The Hale Literary Readers: Book One*. New York: World Book Company, 1925.

Hartwell, E. C. *Story Hour Readings: Fourth Year*. New York: American Book Company, 1921.

Lane, Abby E., ed. *Lights to Literature: Book Four*. Chicago and New York: Rand, McNally & Company, 1900.

Lee, Edna Henry. *The Lee Readers: Second Book*. New York: American Book Company, 1902.

VanSickle, James H. Van, and Wilhelmina Seegmiller, eds. *Third Reader: The Riverside Readers.* Boston: Houghton Mifflin and Company, 1911.

————. *Fifth Reader: The Riverside Readers.* Boston: Houghton Mifflin and Company, 1912.

WORKS BY CELIA LAIGHTON THAXTER IN ANTHOLOGIES & COLLECTIONS

Christmas Carols and Midsummer Songs by American Poets. Boston: D. Lothrop and Company, 1881.

Flowers for a Friend. Fort Worth, TX: Brownlow Publishing Company, 1995.

A Memorable Murder. Vol. 3, Stories by American Authors. New York: Charles Scribner's Sons, 1884.

Adams, Oscar Fay, ed. *March.* Boston: D. Lothrop and Company, 1886.

Baker, George M. *Ballads of Home.* Boston: Lee and Shepard, 1877.

Barbe, Waitman. *Famous Poems Explained.* New York: Hinds, Noble & Eldredge, 1909.

Cook, Ferris, ed. *Invitation to the Garden: A Celebration in Literature & Photography.* New York: Stewart, Tabori & Chang, 1992.

Currier, Mary M., ed. *A Summer in New Hampshire: Out-of-Door Songs for All Who Love the Granite State.* Concord, NH: Rumford Printing Company, 1904.

Drake, Samuel Adams. *A Book of New England Legends and Folk Lore: In Prose and Poetry.* Boston: Little, Brown and Company, 1901.

Garmey, Jane, ed. *The Writer in the Garden.* Chapel Hill, NC: Algonquin Books, 1999.

Gilman, Clarabel, ed. *Songs of Favorite Flowers: Choice Selections from the Less Familiar Poems of Notable Authors.* Boston: James H. West Company, 1900.

Griswold, Rufus Wilmot. *The Female Poets of America.* New York: James Miller Publisher, 1873.

Griswold, Rufus Wilmot. *The Female Poets of America.* New York: James Miller Publisher, 1848.

Hale, Nancy. *New England Discovery: A Personal View.* New York: Coward-McCann, Inc., 1963.

Hall, Donald. *The Oxford Book of Children's Verse in America.* New York: Oxford University Press, 1985.

Handford, Thomas W., ed. *Our Girls: Stories and Poems for Little Girls.* Chicago: Belford, Clarke & Company, 1889.

Hughes, Holly, ed. *Gardens: Quotations on the Perennial Pleasures of Soil, Seed and Sun.* Philadelphia: Running Press Book Publishers, 1994.

Kramer, Jack. *Women of Flowers: A Tribute to Victorian Women Illustrators.* New York: Stewart, Tabori & Chang, 1996.

Leonard, Henry C. *Pigeon Cove and Vicinity.* Boston: F. A. Searle, 1873.

Maggie, Rosalie, ed. *The New Beacon Book of Quotations by Women.* Boston: Beacon Press, 1996.

Morton, Agnes H., ed. *Quotations.* Philadelphia: The Penn Publishing Company, 1893.

Older, Julia, ed. *Celia Thaxter: Selected Writings.* Hancock, NH: Appledore Books, n.d.

Rayne, M. E. *What Can a Woman Do: Or, Her Position in the Business and Literary World.* Petersburgh, NY: Eagle Publishing Company, 1893.

Rittenhouse, Jessie B., ed. *The Little Book of American Poets: 1787–1900.* Boston and New York: Houghton Mifflin and Company, 1915.

Robbins, Maria Polushkin, ed. *A Gardener's Bouquet of Quotations.* Hopewell, NJ: Ecco Press, 1998.

Sharp, Mrs. William, ed. *Sea Music: An Anthology of Poems and Passages Descriptive of the Sea.* Series editor, William Sharp. *The Canterbury Poets.* London: W. J. Gage & Company, n.d.

Stedman, Edmond Clarence, ed. *An American Anthology: 1787–1900*. Boston, New York, Chicago: Houghton Mifflin and Company, 1900.

Sullivan, Charles, ed. *America in Poetry: With Paintings, Drawings, Photographs and Other Works of Art*. New York: Harry N. Abrams, Inc., 1988.

_____, ed. *American Beauties: Women in Art and Literature*. New York: Harry N. Abrams, Inc., 1993.

Tappan, Edith Haskell, ed. *An Anthology of New Hampshire Poetry*. Manchester, NH: The Clarke Press, 1938.

Van Dyke, Henry, ed. *The Poetry of Nature*. New York: Doubleday, Page & Company, 1909.

Whittier, John Greenleaf, ed. *Selections from Child Life in Poetry and Child Life in Prose*. Vol. 70 and 71, The Riverside Literature Series. Boston: Houghton Mifflin and Company, 1894.

Yager, Cary O., ed. *The Gardener's Book of Poems and Poesies*. Chicago: Contemporary Books, Inc., 1996.

References to Celia Laighton Thaxter

Books, Edited Books, Book Sections & Exhibition Catalogues

American Heritage Dictionary. Second College Edition. Boston: Houghton Mifflin and Company, 1982.

Appleton's Cyclopedia of American Biography. Vol. 6, 1889.

Attractive Bits Along Shore. Portland, ME: H. Wilber Hayes, n.d.

A Catalogue of Books and Authors. Boston: Houghton Mifflin and Company, 1905.

Dictionary of American Biography. Vol. 18. New York: Scribner's, 1936.

Encyclopedia Americana. Vol. 26, 1966.

National Cyclopedia of American Biography, 1898.

New England: A Collection from Harper's Magazine. New York: Gallery Books, 1990.

New Hampshire: A Guide to the Granite State. Boston: Houghton Mifflin and Company, 1938.

Old Kittery: 300th Anniversary Book. Kittery, ME: Piscataqua Press, 1947.

Addison, Daniel Dulany. *Lucy Larcom: Life, Letters and Diary*. Boston: Houghton Mifflin and Company, 1895.

Aldrich, Thomas Bailey. *An Old Town by the Sea*. Boston and New York: Houghton Mifflin and Company, 1893.

American Mothers Committee, Inc., ed. *Mothers of Achievement in American History 1176–1976*. Rutland, VT: The Charles E. Tuttle Company, Inc., 1976.

Anderson, Lorraine, ed. *Sisters of the Earth: Women's Prose and Poetry About Nature*. New York: Random House, Inc., 1991.

Bacon, Edwin M. *Literary Pilgrimages in New England*. New York: Silver, Burdett and Company, 1902.

Bardwell, John D. *The Isles of Shoals: A Visual History*. Portsmouth, NH: Portsmouth Marine Society, Peter E. Randall Publisher, 1989.

Barnes, Mary R., J. Elizabeth Cate, Cassie M. Colby, Laura M. Gould, Elizabeth J. McKelvie, and Emma L. McLaren. *A Brief History of New Hampshire*. Manchester, NH: The Clark Press, n.d.

Barnes, Walter. *The Children's Poets*. Yonkers on Hudson, NY: World Book Co., 1925.

Bennett, Paula Bernat, ed. *Nineteenth Century American Women Poets: An Anthology*. Malden, MA: Blackwell Publishers, Inc., 1998.

Bigelow, Rev. E. Victor. *Brief History of the Isles of Shoals*. Boston: Congregational Summer Conference, 1923.

Blanchard, Mary Warner. *Oscar Wilde's America: Counterculture in the Gilded Age*. New Haven and London: Yale University Press, 1998.

Blanchard, Paula. *Sarah Orne Jewett: Her World and Her Work,* Radclifffe Biography Series. Reading, MA: Addison-Wesley Publishing Co., 1994.

Boden, Gary T. *The Vascular Flora of Appledore Island*. Ithaca, NY: Shoals Marine Laboratory at Cornell University, 1997.

Botkin, B. A., ed. *A Treasury of New England Folklore: Stories, Ballads and Traditions of Yankee Folk*. New York: Bonanza Books, 1947.

Bowles, Ella Shannon. *Let Me Show You New Hampshire*. New York: Alfred A. Knopf, 1938.

Boyle, Richard J. *American Impressionism*. Boston: New York Graphic Society, 1974.

Brewster, Lewis W. *Historical Souvenir of the Isles of Shoals*. Portsmouth, NH: Arthur G. Brewster, 1910.

Bronson, A. M., and C. Walter. *A Short History of American Literature*. Boston: D. C. Heath & Co., Publishers, 1900.

Brooks, Paul. *Speaking for Nature*. Boston: Houghton Mifflin and Company, 1980.

Brooks, Van Wyck. *The Flowering of New England: 1815–1865*: E. P. Dutton & Co., Inc., 1937.

_____. *New England Indian Summer 1865–1915*. Hardcover. New York: E. P. Dutton and Company, 1940.

_____. *New England Indian Summer 1865–1915*. Paperback. Chicago: University of Chicago Press, 1984.

Buell, Lawrence. *The Environmental Imagination: Thoreau, Nature Writing and the Formation of American Culture*. Cambridge, MA: Harvard University Press, 1995.

Buffam, Francis H., ed. *New Hampshire . . . In Miniature*. Concord: State of New Hampshire, 1951.

Burke, Doreen Bolger. "In Pursuit of Beauty: Americans and the Aesthetic Movement." In *In Pursuit of Beauty —- Oct. 23, 1986–Jan. 11, 1987*. New York: Metropolitan Museum of Art, 1986.

Burroughs, John. *Birds and Poets: With Other Papers*. New York: Hurd and Houghton, 1878.

Caldwell, Bill. *Islands of Maine: Where America Really Began*. Portland, ME: Guy Gannett Publishing Co., 1981.

Chapin, Bela, ed. *The Poets of New Hampshire*. Claremont, NH: Charles H. Adams, Publisher, 1883.

Cheney, Ednah D., ed. *Louisa May Alcott: Her Life, Letters, and Journals*. Boston: Roberts Brothers, 1890.

Coolbrith, Ina Donna. *The Singer of the Sea: In Memory of Celia Thaxter*: The Century Club of California, 1894.

Cornish, Louis C. *The Story of the Isles of Shoals*. Boston: The Beacon Press, Inc., 1936.

Coult, Margaret, ed. *Letters from Many Pens: A Collection of Letters*. New York: The Macmillan Company, 1923.

Curry, David Park. "Childe Hassam: An Island Garden Revisted." Denver and New York: Denver Art Museum in association with W. W. Norton & Co., 1990.

Davidson, Cathy N., and Linda Wagner-Martin, eds. *The Oxford Companion to Women's Writing in the United States*. New York: The Hearst Corp., 1991.

Delamar, Gloria T. *Louisa May Alcott and "Little Women": Biography, Critique, Publications, Poems, Songs and Contemporary Relevance.* Jefferson, NC, and London: McFarland & Company, Inc., 1990.

Donovan, Josephine. *New England Local Color Literature: A Women's Tradition.* New York: Frederick Ungar Publishing Co., 1983.

Drake, Samuel Adams. *Nooks and Corners of the New England Coast.* New York: Harper & Brothers, Publishers, 1875.

Emmet, Alan. *So Fine a Prospect: Historic New England Gardens.* Hanover, NH: University Press of New England, 1996.

Faust, Langdon Lynne, ed. *American Women Writers: A Critical Reference Guide from Colonial Times to the Present.* Vol. 2. New York: Frederick Ungar Publishing Co., 1983.

Faxon, Susan C. *A Stern and Lovely Scene: A Visual History of the Isles of Shoals.* Durham: University of New Hampshire Art Galleries, 1978.

Fell, Derek. *The Impressionist Garden.* New York: Carol Southern Books, 1994.

Fetterley, Judith. "Theorizing Regionalism: Celia Thaxter's Among the Isles of Shoals." In *Breaking Boundaries: New Perspectives on Women's Regional Writing,* edited by Sherrie and Diana Royer Inness, pp. 8, 38–53. Iowa City: University of Iowa Press, 1997.

Fetterley, Judith, and Marjorie Pryse, eds. *American Women Regionalists, 1850–1910.* New York: Norton, 1992.

Fields, Annie. *Authors and Friends.* 4th ed. Boston: Houghton Mifflin and Company, 1897.

————. *Letters of Sarah Orne Jewett.* Boston and New York: Houghton Mifflin and Company, 1911.

Fields, James. *Yesterdays with Authors.* Boston: Houghton Mifflin and Company, 1882.

Fields, James T. *Biographical Notes and Personal Sketches: Unpublished Fragments and Tributes from Men of Letters.* Boston: Houghton Mifflin and Company, 1892.

Foshay, Ella M. *Reflections of Nature.* New York: Alfred A. Knopf, 1984.

Garvin, James L. *Historic Portsmouth.* Somerworth, NH: NH Publishing Company, 1974.

Giffen, Sarah L., and Kevin D. Murphy, eds. *A Noble and Dignified Stream: The Piscataqua Region in the Colonial Revival, 1860–1930.* York, ME: Old York Historical Society, 1992.

Gilmore, Robert C. *New Hampshire Literature.* Hanover, NH: University Press of New England, 1981.

Gilmore, Robert C., and Bruce E. Ingmire. *The Seacoast New Hampshire: A Visual History.* Norfork, VA: The Donning Company, Publishers, 1989.

Hammond, Otis G. *Some things about New Hampshire: an address before the Rotary Club of Concord, N.H., Jan. 5, 1926.* Concord, NH: New Hampshire Historical Society, 1930.

Hanaford, Phebe A. *Daughters of America; or, Women of the Century.* Augusta, ME: True and Company, 1882.

Haverstick, Iola S., Jean W. Ashton, Caroline F. Schimmel, and Mary C. Schosser. "Emerging Voices: American Women Writers 1650–1920." In *Emerging Voices,* 120. New York: The Grolier Club, 1998.

Hawthorne, Nathaniel. *The American Notebooks.* Columbus: Ohio State University Press, 1974.

Hiesinger, Ulrich W. *Child Hassam, American Impressionist.* New York: Prestel-Verlag, 1994.

Higginson, Thomas Wentworth. *Old Cambridge.* New York: The Macmillan Company, 1899.

Hill, May Brawley. *Grandmother's Garden: The Old-Fashioned American Garden 1865–1915.* New York: Harry N. Abrams, Inc., 1995.

Hobhouse, Penelope. *Garden Style.* Minocqua, WI: Willow Creek Press, 1988.

Hoopes, Donelson F. *Childe Hassam.* New York: Watson-Guptill Publications, 1979.

Hoppin, Martha J. *William Morris Hunt: A Memorial Exhibition.* Museum of Fine Arts, Boston, 1979.

Howard, Richard A. *Flowers of Star Island, the Isles of Shoals.* Jamaica Plain, MA: Arnold Arboretum, 1968.

Howe, Mark Anthony DeWolfe. *Memories of a Hostess: A Chronicle of Eminent Friendships Drawn Chiefly from the Diaries of Annie Fields.* Second printing. Boston: St. Martin's Press, 1922.

Howells, William Dean. *Literary Friends and Acquaintance.* New York: Harper & Brothers Publishers, 1902.

Inness, Sherrie A., and Diana Royer, eds. *Breaking Boundaries: New Perspectives on Women's Regional Writing.* Iowa City: University of Iowa Press, 1997.

James, Edward T. *Notable American Women 1607–1950: A Biographical Dictionary.* Vol. 3. Cambridge, MA: The Belknap Press of Harvard University Press, 1971.

Jenness, John Scribner. *The Isles of Shoals: An Historical Sketch.* Boston: Houghton Mifflin and Company, 1875.

_____. *The Isles of Shoals: An Historical Sketch.* Paperback. Portsmouth, NH: Peter E. Randall Publisher, 1975.

Jesup, Peter Paul, and John Bowdren. *The Lady Ghost of the Isles of Shoals.* Portsmouth, NH: Seacoast Publications, 1992.

_____. *A December Gift from the Shoals.* Portsmouth, NH: Seacoast Publications, 1993.

Jewett, Sarah Orne. *Letters of Sarah Orne Jewett,* ed. Annie Adams Fields. Boston: Houghton Mifflin and Company, 1882.

Keller, Karl. *The Only Kangaroo among the Beauty: Emily Dickinson and America.* Johns Hopkins Paperback, 1980. Baltimore, MD: The Johns Hopkins University Press, 1979.

Kingsbury, John M. *Here's How We'll Do It: An Informal History of the Construction of the Shoals Marine Laboratory.* Ithaca, NY: Bullbrier Press, 1991.

Knight, Denise D., and Emmanuel S. Nelson, eds. *Nineteenth-Century American Women Writers.* Westport, CT: Greenwood Press, 1997.

Krupinski, Loretta. *Celia's Island Journal.* Boston: Little, Brown, 1992.

Labanaris, Faye. *Blossoms by the Sea.* Paducah, KY: American Quilter's Society, 1996.

Lacy, Allen, ed. *The American Gardener: A Sampler.* New York: Farrar Straus Giroux, 1988.

Lacy, Allen. *The Gardener's Eye and Other Essays.* Paperback. New York: Henry Holt and Company, Inc., 1992.

_____. *The Inviting Garden: Gardening for the Senses, Mind and Spirit.* New York: Henry Holt and Company, 1998.

Laighton, Oscar. *Ninety Years at the Isles of Shoals.* Andover, MA: The Andover Press, 1929.

_____. *Ninety Years at the Isles of Shoals.* Paperback. Boston: The Star Island Corporation, 1971.

_____. *Songs and Sonnets.* Andover, MA: The Andover Press, n.d.

Marchalonais, Shirley, ed. *Patrons and Protegees: Gender, Friendship and Writing in Nineteenth-Century America*. New Brunswick, NJ, and London: Rutgers University Press, 1988.

_____. *The Worlds of Lucy Larcom*. Athens, GA: University of Georgia Press, 1989.

Martin, Tovah. *Victoria: Moments in a Garden*. New York: The Hearst Corp., 1991.

Mason, Caleb. *The Isles of Shoals Remembered: A Legacy from America's First Musicians' and Artists' Colony*. Boston: Charles E. Tuttle Company, Inc., 1992.

Matthieson, Francis Ott. *Sarah Orne Jewett*. Boston and New York: Houghton Mifflin and Company, 1911.

Maynard, Mary. *Dead and Buried in New England*. Dublin, NH: Yankee Books, 1993.

McGill, Frederick T., ed. *Letters to Celia: Written During the Years 1860–1875 by Her Brother Cedric Laighton*. Boston: The Star Island Corporation, 1972.

_____. *Letters to Celia: Written During the Years 1860–1875 by Her Brother Cedric Laighton*. Portsmouth, NH: Peter E. Randall Publisher, 1996.

McGill, Frederick T., and Virgina F. McGill. *Something Like a Star: A Rather Personal View of the Star Island Conference Center*. Boston: The Star Island Corporation, 1989.

McGuire, Diane Kostial, ed. *American Garden Design: An Anthology of Ideas That Shaped Our Landscape*. New York: MacWilliam, 1994.

Metcalf, H. H. *New Hampshire in History*. Concord, NH: W. B. Ranney Company, 1922.

Meyer, Marilee Boyd. "Inspiring Reform: Boston's Arts and Crafts Movement." In *Inspiring Reform: Boston's Arts and Crafts Movement*, 247. Wellesley, MA: Davis Museum and Cultural Center, 1997.

Molloy, Anne. *Celia's Lighthouse*. Boston: Houghton Mifflin and Company, 1949.

_____. *Celia's Lighthouse*. Paperback. Hampton, NH: Peter E. Randall Publisher, 1976.

Myers, M. *Celia Thaxter: An Anthology in Memoriam (1835–1894)*. Bristol, IN: Bristol Banner Books, 1994.

Neuberger, Julia, ed. *The Things That Matter: An Anthology of Women's Spiritual Poetry*. New York: St. Martin's Press, 1995.

Norwood, Vera. *Made from This Earth: American Women and Nature*. Chapel Hill: University of North Carolina Press, 1993.

Ohrbach, Barbara Milo. *Simply Flowers: Practical Advice and Beautiful Ideas for Creating Flower-Filled Rooms*. New York: Clarkson N. Potter Inc., 1993.

Olcott, Charles S. *The Lure of the Camera*. Boston and New York: Houghton Mifflin and Company, 1914.

Older, Julia. *The Island Queen: A Novel*. Hancock, NH: Appledore Books, 1994.

Oppel, Frank, ed. *Tales of the New England Coast*. Secaucus, NJ: Castle, a division of Book Sales, Inc., 1985.

Parton, James. *Noted Women of Europe and America*. Hartford, CT: Phoenix Publishing Company, 1883.

Pattee, Fred Lewis, ed. *Century Reading for a Course in American Literature*. New York: The Century Company, 1919.

Phelps, Elizabeth Stuart. *Chapters from a Life*. Boston: Houghton Mifflin and Company, 1896.

Pickard, Samuel Thomas. *Life and Letters of John Greenleaf Whittier*. Boston: Houghton Mifflin and Company, 1894.

_____. *Whittier-Land: A Handbook of North Essex*. Boston: Houghton Mifflin and Company, 1904.

Piscataqua Garden Club, ed. *Piscataqua Papers: Gardening from the Merrimack to the Kennebec.* Boston: Thomas Todd Co., 1965.

Pollard, John A. *John Greenleaf Whittier: Friend of Man.* Boston: Houghton Mifflin and Company, 1949.

Powers, G. W. *Crowell's Handy Information Series,* Important Events. Boston, 1899.

Randall, Peter E. *Out on the Shoals: Twenty Years of Photography on the Isles of Shoals.* Portsmouth, NH: Peter E. Randall Publisher, 1995.

Randall, Peter E., and Maryellen Burke, eds. *Gosport Remembered: The Last Village at the Isles of Shoals.* Portsmouth, NH: Peter E. Randall Publisher, 1997.

Rhodehamel, Josephine DeWitt, and Raymond Francis Wood. *Ina Coolbrith—Librarian and Laureate of California.* Provo, UT: Brigham Young University Press, 1973.

Robinson, J. Dennis. *A Brief History of Portsmouth, New Hampshire.* Portsmouth: Portsmouth Historical Society, 1998.

Robinson, William F. *Coastal New England: Its Life and Past.* Secaucus, NJ: The Wellfleet Press, 1989.

Roman, Judith. *Annie Adams Fields: The Spirit of Charles Street.* Bloomington: University of Indiana Press, 1990.

Rowe, Henry K. *The History of Newton, 1630–1930.* Newton: City of Newton, Massachusetts, 1930.

Rutledge, Lyman V. *The Isles of Shoals in Lore and Legend.* Boston: The Star Island Corporation, 1965.

_____. *Ten Miles Out: Guide Book to the Isles of Shoals.* Boston: Isles of Shoals Unitarian Association, 1949.

_____. *Ten Miles Out: Guide Book to the Isles of Shoals,* edited by Edward F. Rutledge. Portsmouth, NH: Peter E. Randall Publisher, 1997.

Scheffel, Richard L., ed. *Discovering America's Past.* Pleasantville, NY: The Reader's Digest Association, Inc., 1993.

Shaw, John Mackay. *The Poems, Poets and Illustrators of St. Nicholas Magazine, 1873–1943.* Tallahassee: Florida State University Press, 1965.

Sherr, Lynn, and Jurate Kazickas. *Susan B. Anthony Slept Here: A Guide to American Women's Landmarks.* New York: Random House, 1994.

Shi, David E. *Facing Facts: Realism in American Thought and Culture, 1850–1920.* New York: Oxford University Press, 1995.

Simpson, Dorothy. *The Maine Islands: In Story and Legend.* Nobleboro, ME: Blackberry Books, 1987.

Snow, Edward Rowe. *Famous New England Lighthouses.* Boston: The Yankee Publishing Company, 1945.

_____. *True Tales of Buried Treasure.* 1960 revised edition. New York: Dodd, Mead & Company, 1951.

Spofford, Harriet Prescott. *A Little Book of Friends.* Boston: Little, Brown and Company, 1916.

Springer, Haskell, ed. *America and the Sea: A Literary History.* Athens: University of Georgia Press, 1995.

Stearns, Frank Preston. *Sketches from Concord and Appledore.* New York: G. P. Putnam's Sons, 1895.

Stedman, Edmund Clarence. *Poets of America.* Boston and New York: Houghton Mifflin and Company, 1885.

Stoddard, R. H., and Others. *Poets' Homes: Pen and Pencil Sketches of American Poets and Their Homes.* Vol. 1 and 2. Boston: D. Lothrop and Company, 1877.

Sweetser, Mary Chisholm. *Whittier and Appledore.* Malden, MA: Mary Chisholm Sweetser, 1957.

Tardiff, Olive. *They Paved the Way—A History of N.H. Women:* Women for Women Weekly Press, 1980.

Tenenbaum, Frances, ed. *An Island Garden Day Book*. Boston: Houghton Mifflin and Company, 1990.

Thaxter, Rosamond. *Sandpiper: The Life and Letters of Celia Thaxter*. Sanbornville, NH: Wake Brook House, 1962.

_____. *Sandpiper: The Life and Letters of Celia Thaxter*. Marshall Jones Co., 1963.

_____. *Sandpiper: The Life and Letters of Celia Thaxter*. Paperback. Hampton, NH: Peter E. Randall Publisher, 1999.

Thompson, Lovell, M. A. De Wolfe Howe, Arthur Stanwood Pier, and Harford Powel, eds. *Youth's Companion*. Boston: Houghton Mifflin and Company, 1954.

Titus, Donna Marion, ed. *By This Wing: Letters by Celia Thaxter to Bradford Torrey about Birds at the Isles of Shoals, 1888–1894*. Manchester, NH: J. Palmer Publisher, 1999.

Titus, Donna Marion. *Celia Thaxter Coloring Book*. Goffstown, NH: QPS Enterprises, 1992.

Trent, William Peterfield, ed. *Cambridge History of American Literature*. New York: G. P. Putnam's Sons, 1921.

Vallier, Jane E. *Poet on Demand: The Life, Letters and Works of Celia Thaxter*. Camden, ME: Down East Books, 1982.

_____. *Poet on Demand: The Life, Letters and Works of Celia Thaxter*. Portsmouth, NH: Peter E. Randall Publisher, 1997.

Varrell, William M. *Summer by-the-Sea*. Portsmouth, NH: The Strawbery Banke Print Shop, 1972.

Verrill, A. Hayatt. *Along New England Shores*. New York: G. P. Putnam's Sons, 1936.

Walker, Cheryl, ed. *American Women Poets of the Nineteenth Century: An Anthology*. New Brunswick, NJ: Rutgers University Press, n.d.

Warner, Charles Dudley, ed. *Library of the World's Best Literature, Ancient and Modern*. Vol. 25. New York: R. S. Peale and J. A. Hill, 1897.

Westbrook, Perry D. *Acres of Flint: Writers of Rural New England, 1870–1900*. Washington, DC: Scarecrow Press, 1951.

_____. *Seacoast and Upland: A New England Anthology*. South Brunswick and New York: A. S. Barnes and Company, 1972.

Whittaker, Robert H. *Land of Lost Content*. Dover, NH: The Allen Sutton Publishing, Inc, 1993.

Wolfe, Theodore F., M.D., Ph.D. *Literary Shrines: The Haunts of Some Famous American Authors*. 2nd edition. Philadephia: J. B. Lippincott Company, 1895.

Woodbury, Benjamin Collins. *Portsmouth and Other Poems*. Boston: Press of George H. Ellis Co., 1923.

Wright, Catherine Morris. *Lady of the Silver Skates: The Life and Correspondence of Mary Mapes Dodge*. Jamestown: R. L. Clingstone Press, 1979.

References to Celia Laighton Thaxter

Magazines, Journals & Conference Proceedings

The Cottage Hearth, vol. 5, no. 10, October 1878.

"An Island Garden." *Organic Gardening*, September 1989, 13.

"Celia Thaxter's Grave and Garden." *Literary World*, 1899, 265.

"Celia Thaxter's Poems for Autumn Lament the Narrowing Days." *New Hampshire Historical Society Newsletter* 24, no. 5 (1986): 3–5.

"The Editor's Table." *The New England Magazine*, January 1891, 674–78.

"Some Famous Women of New Hampshire." *Granite Monthly*, 1925, 77–83.

"A Place for Thanks Giving." *The Oprah Magazine,* November 2000, 120–22.

Albee, John. "Memories of Celia Thaxter." *The New England Magazine,* April 1901.

Barry, William David. "The Lady and the Painter." *Down East,* 1992, 40–4.

Brandimarie, Cynthia A. "Somebody's Aunt and Nobody's Mother: The American China Painter and Her Work, 1870–1920." *Winterthur Portfolio* 23, no. 4 (1988): 203–24.

Burt, Nathaniel. "Among the Isles of Shoals." *New England Journeys,* 1954, 128.

Burtis, Bill. "The Isles of Shoals." *Oceans,* June 1988, 3–28.

Caldwell-Hopper, Kathi. "Thomas Laighton of Portsmouth . . . And the Isles." *Hampshire East,* December 1993, 61.

Cary, Richard. "The Multi-Colored Spirit of Celia Thaxter." *Colby College Library Quarterly* 6 (1964): 512–36.

Chisholm, Virginia. "Celia Thaxter's Island Garden." *Plants & Gardens, Brooklyn Botanic Garden Record: American Cottage Gardens* 46, no. 1 (1990): 62–67.

Clark, Tim. "Shoals Marine Laboratory." *Yankee Magazine,* February 1987, 41–42.

Cotton, Arthur Everett. "New Hampshire Authors." *Granite Monthly,* 1887, 214–18.

Dow, Edward. "New Hampshire Necrology." *Granite Monthly,* 1894, 220.

Dunhill, Priscilla. "Poet Celia Thaxter: An Island Gardener." *Victoria,* July 1990, 32–39.

Fields, Annie. "Celia Thaxter." *The Atlantic Monthly,* February 1895, 254.

Fowler, William Plumer. "Celia Thaxter and Her Birds." *New Hampshire Bird News: NH Audubon Society* 13, no. 3 (1960): 78–83.

Fredrick, Elizabeth H. "Fifty Years of Fellowship: An Anniversary for Star Island." *The Register-Leader: The Unitarian Universalist,* April 1966, 3–5.

Gardner, JoAnn. "In Grandmother's Garden." *Old-House Journal,* October 2000, 49–53.

Gibson, Robin. "Inside a Nineteenth Century Salon and Garden: Celia Thaxter and Childe Hassam." In *Reynolda House Museum of American Art.* Winston-Salem, NC, 1994.

Grimke, Charlotte Forten. "Personal Recollections of Whittier." *The New England Magazine,* June 1893, 468–76.

Howells, William Dean. "Literary Boston Thirty Years Ago." *Harper's New Monthly Magazine,* June–November 1895, 865–79.

Hunt, Elmer Munson. "When New Hampshire's Greenland Was Established under Queen Anne in 1704." *Historical New Hampshire,* September 1954, 1–11.

Jacobs, Katharine L. "Celia Thaxter and Her Island Garden." *Landscape,* 1980, 12–17.

Jewell, M. H. "An Early Letter by Celia Thaxter." *Old Time New England* XXXVII, no. 4 (1947): 101–03.

Johnson, Thomas B. "New England Colonial Revival." *Old-House Interiors,* November 1999, 54–62.

Kageleiry, Jamie F. "Celia's Garden." *Yankee,* August 1994, 60.

Kamm, Dorothy. "Celia Thaxter: China Paintings Fit for Fairies." *Dorothy Kamm's Porcelain Collector's Companion* 8, no. 2. (1999).

Lamb, Jane. "Hollyhocks, Poppies and Sweet Peas." *Down East,* August 1986, 76.

Lee, Gerald Stanley. "Celia Thaxter." *The Critic,* March 1896, 209.

Logan, William Bryant. "Impressions of an Island." *House and Garden,* June 1990, 42.

Margaret, Dorothy. "Mrs. Laighton's Crullers." *Early American Life,* no. 4 (1973): 25.

Martin, Tovah. "Celia Thaxter's Inspired Life." *Victoria,* April 1997, 18.

May, Stephen. "In an Island Garden: Childe Hassam's Vision of the Isles of Shoals." *Islands,* July–August 1990, 90–99.

————. "An Island Garden: A Poet's Passion, a Painter's Muse." *Smithsonian,* December 1990, 68–76.

————. "Island Garden." *Historic Preservation,* September–October 1991, 38.

McGill, Frederick T., Jr. "Who Remembers Gosport?" *New Hampshire Profiles,* July 1973, 54ff.

Metcalf, H. H. "The Story of the Isles of Shoals." *Granite Monthly,* 1914, 231–45.

Montgomery, Susan J. "Forgotten Treasures." *New Hampshire Home,* March–April 1995, 26–31.

Moore, Aubertine Woodward. "The Story of the Isles of Shoals." *The New England Magazine,* July 1898.

Moses, J. M. "The Isles of Shoals." *Granite Monthly,* 1911, 284–86.

Neagle, Marjorie Spiller. "Appledore—Maine's House of Entertainment." *Down East,* July 1963, 34ff.

Nevins, Deborah. "Poet's Garden, Painter's Eye." *House & Garden,* August 1984, 93ff.

————. "The Triumph of Flora: Women and the American Landscape, 1890–1935." *The Magazine Antiques,* April 1985, 904–19.

Rayfield, Susan. "Blossoms by a Summer Sea." *Americana,* May–June 1990, 28–34.

Reed, Helen Leah. "Celia Thaxter and Her Island Home." *New England Magazine,* November 1893, 208.

Rennicke, Rosemary G. "A Sea of Flowers." *Country Home Country Garden,* fall 1994, 48–52.

Rutledge, Lyman V. "A Kingdom in the Sea." *New Hampshire Profiles,* August 1967.

Sanborn, Frank B. "Lowell, the Home and Haunts." *New England Magazine,* November 1891, 300–01.

Schenker, Heath, and Suzanne Ouelette. "The Garden as Women's Place: Celia Thaxter and Mariana Van Rensselaer." In *Gendered Landscapes Conference.* Penn State, 1999.

Scott, Darcy. "Lure of the Isles of Shoals." *Maine: Boats & Harbors,* September 1997, 8–15.

Scotto, Barbara. "An Island Garden." In *Wilson Library Bulletin,* 1989.

Slover, Kimberley Swick. "Islands in Time." *University of New Hampshire Magazine,* spring 2000.

Stubbs, M. Wilma. "Celia Thaxter, Poet of Nature." *Nature Magazine,* June 1935, 297–98.

————. "Celia Laighton Thaxter, 1835–1894." *New England Quarterly 8,* December (1935): 518–33.

Tankard, Judith. "An Impressionist's Garden: Celia Thaxter's Island Garden." *Labyrinth* 2 (1992): 8–9.

Tardiff, Olive. "Sweet Bird of the Isles of Shoals." *Beacon of Portsmouth,* April 1977, 4–10.

Thaxter, Rosamond. "My Grandmother's Garden on the Isles of Shoals." *New Hampshire Profiles,* April 1989, 48ff.

Thompson, Margo Hobbs. "Brimful of Sentiment and Beauty: Celia Thaxter and Childe Hassam in the Isles of Shoals." In *Washburn Humanities Seminar: Turning Points in 19th Century Northern New England*. Bucknell University, Lewisburg, PA, 1999.

Thorpe, Patricia. "Garden Plots." *House and Garden*, May 1989, 90–91.

Todisco, Patrice. "By Pen and Spade." *Hortus: A Gardening Journal*, 1990, 34–35.

Tozer, Eliot. "Secret Gardens." *New Hampshire Profiles*, May–June 1991, 28–33.

_____. "The Phoenix Garden." *Modern Maturity*, April/May 1992.

Vallier, Jane. "The Role of Celia Thaxter in American Literary History: An Overview." *Colby Library Quarterly* XVII, no. 4 (1981): 238–55.

Vaughn, Dorothy. "Celia Thaxter's Library." *Colby College Quarterly* 6 (1964): 536–50.

Ward, Gerald W. R. "Hand-Painted China by Celia Thaxter." *Antiques and the Arts Weekly*, August 4, 1989.

_____. "Three Centuries of Life Along the Piscataqua River." *The Magazine Antiques*, July 1992, 104–09.

Westbrook, Perry D. "Celia Thaxter's Controversy with Nature." *New England Quarterly* 20, December (1947): 492–515.

_____. "Celia Thaxter: Seeker of the Unattainable." *Colby College Quarterly* 6 (1964): 500–12.

White, Barbara A. "Legacy Profile: Celia Thaxter (1835–1894)." *Legacy: A Journal of American Women Writers* 7 (1990): 1.

THESES ON CELIA LAIGHTON THAXTER

Bearden, Robin Leah. "Celia Thaxter's Salon on Appledore." Master's thesis, Rhodes College, 1992.

Bowles, Mariette. "Celia Thaxter." Master's thesis, University of New Hampshire, 1937.

De Piza, Mary Dickson. "Celia Thaxter: Poet of the Isles of Shoals." Ph.D. diss., University of Pennsylvania, 1955.

Kingsbury, Johanna M. "The Identity and Source of Plants Celia Thaxter Grew in Her Garden." Honors paper, Colgate University, 1979.

Loving, P. M. "Bio-Bibliography of Celia Thaxter, 1835–1894." Master's thesis, University of Minnesota, 1966.

Moulton, Nathalie Marion. "Celia Thaxter—Singer of the Sea." Master's thesis, Cornell University, 1936.

In Her Footsteps

May this selected list of primary sites and resources help to inspire the continued research and study of the life of Celia Laighton Thaxter.

Boston Public Library, Boston, Massachusetts

Celia's Recreated Garden, Appledore Island, Isles of Shoals

Clark Historical Library, Central Michigan University

Dimond Library, University of New Hampshire, Durham,
 New Hampshire

Houghton Library, Harvard University, Cambridge, Massachusetts

Henry E. Huntington Library and Museum, San Marino, California

Isles of Shoals Historical and Research Association, Portsmouth,
 New Hampshire

Miller Library, Colby College, Waterville, Maine

New York Public Library, New York, New York

Portsmouth Athenaeum, Portsmouth, New Hampshire

Portsmouth Public Library, Portsmouth, New Hampshire

Princeton University Library, Princeton, New Jersey

Rice Library, Kittery, Maine

Sarah Orne Jewett House, Society for the Preservation of
 New England Antiquities, South Berwick, Maine

SeacoastNH.com

Strawbery Banke, Portsmouth, New Hampshire

Tuck Library, New Hampshire Historical Society, Concord,
 New Hampshire

University of California, Berkeley, California

University of New England, Westbrook College Campus,
 Portland, Maine

University of Virginia, Charlottesville, Virginia

Vaughn Cottage Memorial Library and Museum, Star Island,
 Isles of Shoals

Whittier Home, Amesbury, Massachusetts

Index

About the Authors

J. Dennis Robinson writes and lives in Portsmouth, New Hampshire. He is editor of the award-winning regional web site SeacoastNH.com that features thousands of pages of information about Seacoast history, culture, business, touring, and the arts.

Norma H. Mandel received a Ph.D. in English from the Graduate Center of the City University of New York. She is currently teaching in the Education Program at Barnard College and writing a biography of Celia Thaxter. She and her husband live in Piermont, New York.

Jane Vallier is the author of *Poet On Demand: The Life, Letters and Works of Celia Thaxter*, University Press of New England, 1994, 1982. She has also edited Thaxter's *Poems* (1996) and has written several scholarly articles on the Thaxter literary legacy. She has spent her academic career in the English Department at Iowa State University, Ames, Iowa. She holds a Ph.D. in English from the University of Colorado.

Nancy Wetzel writes and lectures on turn-of-the-twentieth-century garden history and the notable plantswomen of that period. She is a landscape gardener with a specialty in the design and care of perennial gardens. Ms. Wetzel's practice, located in South Berwick, Maine, includes the gardens at the home, now a museum, of writer Sarah Orne Jewett, a friend and neighbor of Celia Thaxter.

Sharon Paiva Stephan, Curator of *One Woman's Work: The Visual Art of Celia Laighton Thaxter*, holds a Master of Arts degree from the University of Alabama in Birmingham and is currently a Candidate for Certification in Museum Studies from Harvard University. Stephan has co-authored a script for the theatrical production, *Of Pirates and Poets— A Visit to the Isles of Shoals with Celia Thaxter*. Presently her primary area of research is the visual art of Celia Thaxter. She is currently working on a comprehensive bibliography with collectors' guide on Thaxter's life and work. Presenting various lectures and slide programs nationally, she also collects related books, postcards, stereoviews, and ephemera. A New Hampshire native, she lives in Hollis with her husband Bill.

CREDITS

Exhibition Steering Committee
Maryellen Burke
Jonathan Hubbard
Peter Lamb
Sharon Paiva Stephan
Vicki C. Wright

Exhibition Team
Linda Anderle
Rose C. Eppard
Thomas H. Hardiman Jr.
Patricia Heard
Gayle Patch Kadlik
John Mayer
Stephanie Voss Nugent
Donna Marion Titus
Sherry Wood

Photography
For his time, talent, and patience,
a very sincere thank you to Gary Samson.

Additional photography
Linda Anderle, pages 98, 130 (bottom), 131
Tanya M. Jackson, page 79
Bill Stephan, pages 22, 68, 96, 101, 130 (top)

Design
Martha de Lyra Barker

THE SUNRISE NEVER FAILED US YET

Upon the sadness of the sea
The sunset broods regretfully;
From the far lonely spaces, slow
Withdraws the wistful afterglow.

So out of life the splendor dies;
So darken all the happy skies;
So gathers twilight, cold and stern;
But overhead the planets burn;

And up the east another day
Shall chase the bitter dark away;
What though our eyes with tears be wet?
The sunrise never failed us yet.

The blush of dawn may yet restore
Our light and hope and joy once more.
Sad soul, take comfort, nor forget
That sunrise never failed us yet!

Inscribed calling card.
Courtesy Bill and Sharon
Stephan.